An Introduction to
DRAWING AND PAINTING
WITH PASTELS

An Introduction to
DRAWING AND PAINTING
WITH PASTELS

Diana Constance

CHARTWELL
BOOKS, INC.

A QUINTET BOOK

Published by Chartwell Books
A Division of Book Sales, Inc.
110 Enterprise Avenue
Secaucus, New Jersey 07094

ISBN 1-55521-567-X

This book was designed and produced by
Quintet Publishing Limited
6 Blundell Street
London N7 9BH

Creative Director: Peter Bridgewater
Designer: Sally McKay
Project Editor: Sally Harper
Editor: Hazel Harrison

Typeset in Great Britain by
Central Southern Typesetters, Eastbourne
Manufactured in Hong Kong by
Regent Publishing Services Limited
Printed in Hong Kong
by Kwong Fat Offset Printing Company Limited

Unless otherwise credited, all paintings and drawings reproduced
in this volume are the author's own work.

The publishers wish to thank the museums and art galleries
who provided images for reproduction in this book.

CONTENTS

INTRODUCTION

Facing a deadline for an important exhibition, I was searching for a medium which would give me the quality and colour intensity I needed for my images – quickly. The spectre of empty walls on my opening day led me to discover this versatile medium which I have used ever since and now greatly prefer to all others. The intensity of colour and variations of texture make it a marvellous medium for artists whose primary interest is in catching an image rapidly or executing a painting with pure colour and a variety of textures. Each new pastel reveals a fresh possibility for varying and expanding your work. Using the great variety of tints, concentrated in portable sticks, you can become painter and draughtsman all in one – and the colour will remain fresh and permanent. Pastel is not an entirely predictable medium; you will be constantly surprised by the effects of layering a colour, and I find that an exciting interaction develops between my imagination and these subtle colouring sticks as my work develops.

Pastels could be called 'dry paints', as they are made of exactly the same pigments as the finest artists' paints, held very lightly by a gum solution. They have that particular brilliance and clarity of colour that comes from pure pigment, uncorrupted by a heavy binder such as the linseed oil used in oil paints. The density of the colour can be changed by the slightest pressure of the pastel.

You can see the richness of the colour immediately, rising from the working surface, giving great aesthetic pleasure. The need for this kind of tactile stimulation is as old as humanity's desire for self expression – in drawing with charcoal and lumps of dried pigment the cave painters of Lascaux and Altamira were anticipating the pastellist's techniques. The virtues of this essentially archaic medium were appreciated by the contemporaries of Edgar Degas (1834–1917), who was perhaps the greatest exponent of the medium. His friend Huysmans said his nudes 'glorified the disdain of the flesh, as no artist since the Middle Ages has ever dared to do'. Even Renoir, who disliked the medium, was able to say that in Degas' hands it achieved results that 'had the freshness of fresco'.

ONE

PASTELS THROUGH THE AGES

Pastel was 'invented' by Jean Perreal, a minor artist who joined the magnificent retinue of Louis XII in the summer of 1499, hoping to gain fame by recording the French conquest of Northern Italy. He is now remembered only for the revolutionary medium he employed to enhance his sketches, which consisted of pure pigment bound with gum. Its advantages were immediately realized by Leonardo da Vinci (1452–1519), who called it the 'dry colouring method', while his contemporaries named it *pastello*, from *pasta* (paste). He confined its use, however, to highlighting his charcoal and red-chalk drawings, such as that of Isabella d'Este, Duchess of Mantua, where he used yellow in the trimming of her gown and to offset the dark profusion of her hair. Northern Italian artists continued to use it throughout the sixteenth century for portrait sketches and in cartoons for large religious paintings. Its values were enhanced by the use of a distinctive blue-tinted paper, *carta azzurra* and the vivid sense of realism given by the natural flesh and hair tones and eye colour emerging from the smoky-blue background inspired the first royal portraits to be done entirely in pastel, including the le Brun study of an imperious, yet intensely human Louis XIV, now in the Louvre.

THE EIGHTEENTH CENTURY

But it was a bourgeois clientele, and particularly the independent and sophisticated women of the Venetian Republic, who were responsible for the first great surge of popularity in the medium's history, and its true potential was developed by one of these, Rosalba Carriera (1675–1757). A former painter of snuff-boxes, she took up pastels in her middle years and, after drawing a pair of wedding portraits for a grand-duke's daughters, found herself in demand from half of fashionable Italy, and particularly her own city. She then re-exported pastel to its place of origin, France, arriving in Paris in 1720 and producing 50 pastel portraits in barely a year. In spite of her short stay, her influence was huge, with painters clamouring to see and then copy her work.

The frothy, pleasure-seeking *beau monde* of eighteenth-century France, whose lacquered public image was caught by painters such as François Boucher (1703–70) or Perronneau, who

both worked in pastel as well as paint have given the medium something of a reputation for superficiality, but the eighteenth century was also the Age of Enlightenment, and some pastellists took a much cooler, more realistic view of the world. Jean-Baptiste Chardin (1699–1779) only took up pastel when failing eyesight prevented him from painting in oils, but his contribution was important, for he introduced methods of building form both by using parallel slashes of pure pigment and by layering, which anticipated Degas' techniques. His depictions of the everyday world of the bourgeoisie – down to their copper pots and hung game – were later to influence Corot, and ultimately the Impressionists.

The still life was a speciality of another pastellist, the Swiss, Jean Etienne Liotard (1702–89). Concerned above all with realism, he deliberately tilted the plane of the table in one study, to give us a better view of the fruit and other objects on it, foreshadowing Cézanne's ideas about truth to the unchanging realities of form. Liotard had spent some years in Constantinople, in the employ of an English nobleman, and this may well have influenced the direction of his pastel work, giving it a clear-edged yet opulent quality reminiscent of Iznik tiles. This is apparent whether he was drawing a bowl of figs or the enigmatic Countess of Coventry dressed as an odalisque.

Pastel continued to be the chosen medium of prominent women artists, such as Theresa Concordia Mengs, Adelaide Labille-Guard and most important, Elizabeth Vigée-Lebrun (1755–1842) the court favourite in the years before the Revolution.

Long after her death Rosalba Carriera's influence was felt in the work of the young artist whom she had introduced to the medium, Maurice Quentin de Latour (1704–88). His mastery of what he called his 'coloured dust' made him the most sought-after pastel portraitist of the day. 'Unknown to them', he said, 'I descend into the depths of my sitters and bring back the whole man.' But first he had to know himself, and he drew many self portraits, sometimes as the bewigged and confident court artist, and sometimes as the self-aware craftsman, dressed in shirt sleeves and turban.

His technique of broad strokes gave him the confidence to work on a scale never before attempted in pastel, and his masterpiece, the

RIGHT: JEAN-ETIENNE LIOTARD, 1702–89, *Portrait of the Countess of Coventry*, 9¼ × 7½in (23.5 × 19cm), Museum of Art and History, Geneva
One of the most surprising features of this portrait, done on vellum, is the crisp detail, hard to achieve when working on a small scale. It is also a very unusual composition for a pastel of this size, which can perhaps be accounted for by the fact that it is one of three versions. Liotard used the same Turkish costume for all of them, and this work is thought to be a synthesis of two sitters: a Greek slave girl, possibly from the artist's period in Constantinople, and Mary Gunning, later Countess of Coventry. Liotard used much more vibrant colours, predominantly scarlet and cerulean blue, for this version.

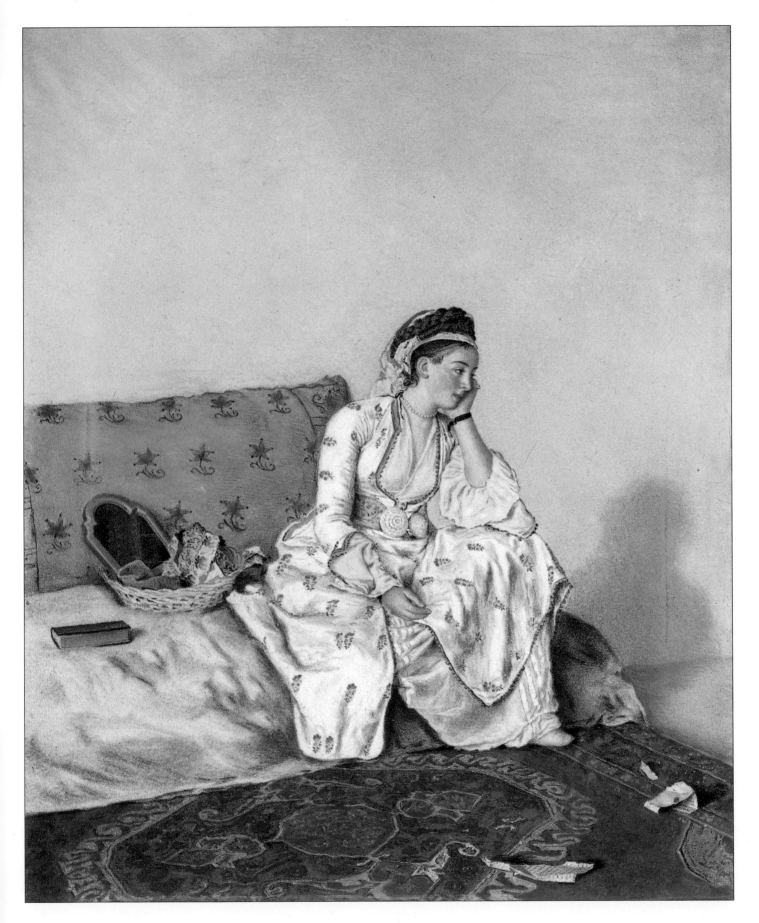

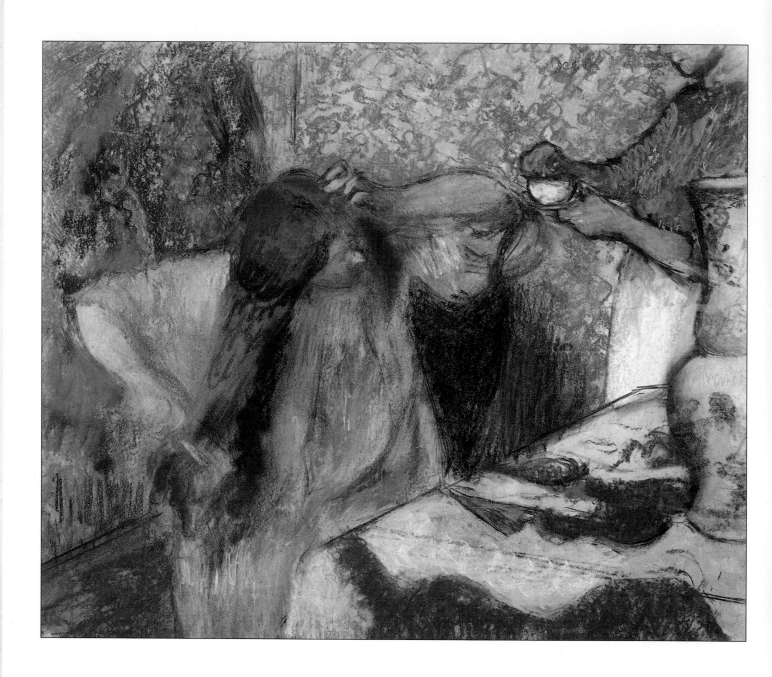

full-length portrait of Madame de Pompadour, now in the Louvre, proved a severe test of nerve as well as skill. With royal sitters, the head was normally sketched at a personal sitting, using a round piece of paper which was later glued in place onto a larger sheet, and the portrait was finished from a stand-in wearing the royal robes. La Pompadour, who was Louis XV's adviser as well as his mistress, gave a series of sittings which were constantly interrupted by the King, until the artist stormed out.

De Latour was subsequently offered only half his agreed fee of 48,000 livres because it was 'something done on paper' (a prejudice that still affects the price of paintings). The portrait, however, was hung in the Salon of 1755 and was one of the twin glories of the great age of the pastellist, the other being his magisterial portrait of the President of the Paris Parlement. Despite the high regard in which De Latour was held, his habit of rebelling against the pseudo-Classical poses popular at the time was controversial.

FROM DELACROIX TO THE IMPRESSIONISTS

The world of the pastel portraitists crashed on July 14 1789 with the outbreak of the Revolution. Not only were they running out of commissions as more and more aristocrats fell to the guillotine, they were also beginning to feel the draught of official disapproval. Their art was associated too much with the frivolity of the *ancien régime*, and pastels were little used until Neo-Classicism in turn, fell before the Romantic offensive. The role of the great Eugène Delacroix (1798–1863) in opening the eyes of a generation which craved emotional stimulation after the loss of empire and glory was crucial. Although the old Bonapartist court painter, Baron Gros, dismissed the young artist's key canvas, *The Massacre at Chios*, as 'le massacre de la peinture,' his experiments with light and colour were a vital factor in the development of Impressionism.

Delacroix used pastels most towards the end of his life, taking them into the countryside to make vivid sketches for his set-pieces. His drawings of cloudscapes and the setting sun made a profound impression on the younger generation who were attempting to formulate a new kind of art. Some of his studies, including the preliminary drawing for *The Death of Sardanapulus*, can be seen in his Paris studio, which is now a museum.

Eugène Boudin (1824–98) used Delacroix as his model in the hundreds of rapid pastel sketches which he executed on the Norman sea-coast. The writer and critic Charles Baudelaire spoke of them as 'these amazing studies, so swiftly and so faithfully jotted down from subjects that cannot be more inconsistent, more elusive in terms of form and colour'.

The Impressionists were profoundly influenced by both the development of photography and the bold, colourful Japanese prints which came into the country in large numbers during the nineteenth century, used as wrapping for imported fine porcelain. Edouard Manet (1832-83) liked to use the pastel stump to blur the outline of his images, giving them the spontaneity of out-of-focus photographs. His first important pastel, of his rather bored wife reclining on a soft blue sofa, is a perfect example of this technique.

Degas, who was a superb draughtsman, was more interested in composition and the depiction of movement than in the play of light on landscape. While his fellow Impressionists concentrated on working outdoors directly from nature with oil paint – although Claude Monet (1840–1926) sometimes used pastel – Degas withdrew to his studio and began his daring experiments on foreshortening or cropping the figures in his compositions and simulating the artificial light of the stage, to give us our first truly modern images. His secret as a pastellist was to build up pigment in successive layers, avoiding the dulling effect of fixative on pastel by making up his own secret formula. This fixed each layer securely without any loss to the brilliance of the tones – the lustrous red hair and creamy skin of his nudes, or the sheen on the coats of his prancing racehorses.

PASTEL IN OUR AGE

At the end of the nineteenth century Odilon Redon (1840–1916) brought pastels to the service of Symbolism. Whereas the Impressionists had used the medium to fix the reality of life, Redon employed them to express the images of the subconscious, valuing it for its ethereal qualities as well as its clear, uncorrupted colour. But he is probably best known for his ravishing flower studies, suffused with colour and light.

Joan Miro (*b* 1893) and Paul Klee (1879–1940) both used pastel in their abstract and semi-abstract work. In *The Woman*, the key painting in Miro's Fauvist series, it is employed in rich, sensuous areas of pure colour, standing out from the buff paper background, while in his anti-war statement, *Woman and Bird in Front of the Sun*, pastel forms the first coat, with patches of gouache worked over it. Whereas Miro preferred the medium for its smooth blending qualities, Klee used it for heavily textured effects as a basis for his abstracts, frequently working over burlap or linen.

So many complex mixtures of media are used today that it is frequently difficult to identify a pastel. How many people, for instance, are aware that some of the of raw colour in Francis Bacon's canvasses, as well as his hazy, smudged techniques, are those same sticks of colour that Boucher used for his frivolous court favourites?

TWO
WAYS
& MEANS

In the past artists always prepared their own materials, a skill which is unfortunately underrated in modern art schools. The sense of satisfaction derived from the discovery of a new colour or technique comes through the diaries and memoirs of artists and craftsmen down the ages, from Albrecht Dürer, recording his delight in making a particular shade of blue, to J. M. W. Turner, arguing with his housekeeper over the mean amount of blue she habitually put out when arranging his palette.

There are very good reasons for learning how to make your own pastels. The better you understand the structure of the material you are working with, the better able you are to maximize its potential. Also, the more expensive, extremely soft, German pastels, important for layering techniques, are difficult to find except in very specialized shops, but with a bit of practice you should be able to make a satisfactory substitute. In addition you will be able to make your own range of colours – those you would buy if using paints. For example, if you are sketching a landscape, you can make a better selection of greens than is available in the manufactured range.

Pastel is a medium which calls for a large range of colours, which you can extend by personal experimentation. There is nothing like actually creating your own tones to break down inhibitions and build confidence. The process of making pastels is explained slightly later in this chapter, but first we will look at the different pastels available and their various uses and applications.

TYPES OF PASTELS

Soft pastels

These, like all pastels, are made from artists' pigment, which is finely ground, and is combined with titanium or zinc white or French chalk. This is mixed in turn with a weak solution of gum tragacanth or gum arabic.

Hard pastels

These are made from the same pigment but contain more gum binder, and are combined with black pigment instead of the white used in soft pastels. The harder sticks that result are capable of being shaped or sharpened and used for fine lines and detail. Because of the admixture of black, the colour appears denser and darker and does not have the luminosity and bloom associated with the soft pastel.

Pastel pencils

These are simply pastels encased in wood. They are both delicate and expensive, and are easily shattered by dropping. They must be carefully sharpened with a craft knife and sanded to a point. They are useful for detailed work and can be used for drawing. They are ideal for use with watercolour, where they can pick out detail and give a charming effect on slightly damp paper.

MAKING SOFT PASTELS

Binders and pigments

Many types of binding solution can be used – strained oatmeal gruel, for example, is a very light binder, suitable with pigments such as madder lake, Prussian blue and cadmium red, which would tend to be quite hard if used with a gum binder. Gum arabic can make the sticks brittle, with a hard crust. The brittleness can be reduced by adding honey or crystallized sugar. Skimmed milk, which provides a weak binding medium, can also be used.

The best binding solution is gum tragacanth. 46.29 grains (three grams) should be added to 2 pints (1 litre) of water and allowed to stand until a jelly is formed. This should be warmed slightly until it becomes a paste. If there is difficulty dissolving the tragacanth, add a small amount of pure alcohol at the outset. A quarter of a teaspoon of beta naphthol, available from specialist suppliers, can be added to the binding solution to preserve it in good condition for storage.

Most artist's pigments are suitable with the exception of Cremnetz white (or flake white), Naples yellow, chrome yellow and emerald green. Breathing in the dust of these colours, especially the latter, can be quite dangerous.

RIGHT: *Weighing the gum to make the binding medium.*

When starting off, it is best to use a small amount of solution and to make only a few sticks at a time so that you can check your results. If the pastels are too hard, more water can be added to the mixture, and if too soft and crumbly, a small amount of gum can be used to top up the original solution.

Method

Place two equal piles, one of pigment and the other of zinc white, on a piece of newspaper. The piles can be mixed easily by slightly lifting the edges of the paper and rolling the two pigments together. Another method of working, which eliminates all dust, is to put the two powders into small plastic bags, such as sandwich bags, and close the tops firmly before shaking the pigments together.

Next place the mixture on a piece of glass or board, and divide it in half. One half is used to make the colour while the other part is retained to make the graduated tones of the colour. This is done by adding an equal amount of white to the left-over mixture, dividing it in half and then repeating the process, adding white in equal amounts each time. The half retained can be placed at the side of the glass or put in a bag.

Add the gum mixture very slowly to form a thick paste and then mix this thoroughly with a palette knife. It is helpful to allow the mixture to rest for a short time so that the pigment can absorb the solution thoroughly. You may notice the paste softening slightly during this process.

When the mixture is ready, collect some of it on the palette knife and roughly shape it into a stick. Put this on a piece of blotting paper or other absorbent paper, and roll it into the finished shape, using another piece of absorbent paper. Generally, handmade pastels should be thicker than manufactured ones, to give them additional strength. Completed sticks are then laid out on more absorbent paper and left to dry naturally, a process which will take 48 hours. Small squares or triangles, useful for laying in backgrounds, can be made in the same way.

Inevitably, small pieces and fragments of pastels will be left from your work. These can be divided into piles of similar colours and ground with a pestle and mortar. Add a small amount of skimmed milk and form into new sticks.

1

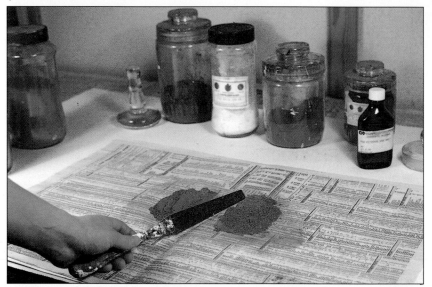

4

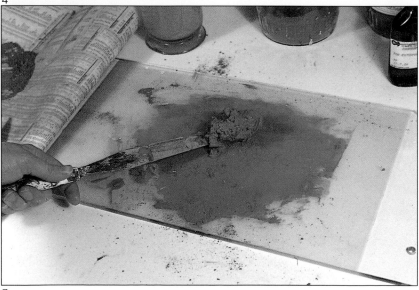

7

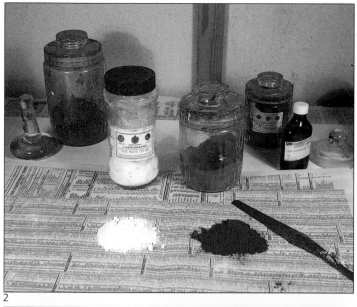

2

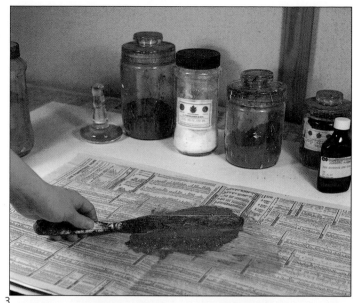

3

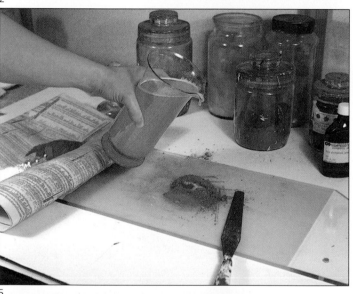

5

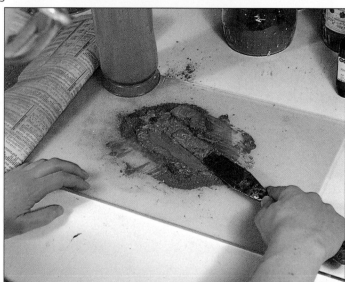

6

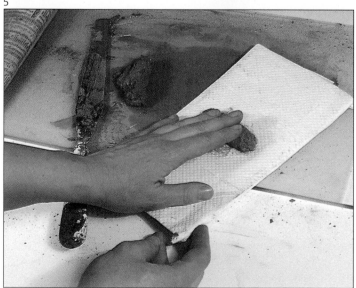

8

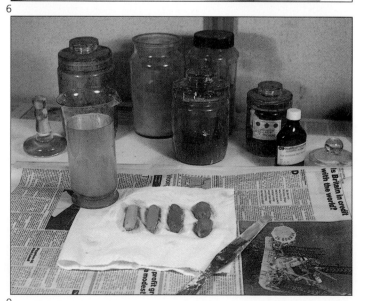

9

SUPPORTS

The term refers to the ground used for the drawing, whether paper, board or fabric. Texture is a vital part of pastel work, and so the choice of surface is critical to the success of the finished picture.

You should first consider your subject and the mood you want to capture. A subtle study of flowers, for instance, with delicate, smooth petals and bright colour, may require a completely different support to a windswept landscape or busy cityscape. The smoother surfaces allow you to blend the colours smoothly and evenly, while rougher ones provide a vigour and sparkle that may suit your purposes better.

Fine-grained supports

Commercially produced pastel board comes in several textures, and the smoothest grade, velour, gives a very good result for blending and sharply detailed work.

If you want a smooth surface, board is better than paper because it is rigid and there is less chance of the pastel flaking or dropping off. A smooth flexible surface constantly loses pastel because the shallow grain of the paper will not grip and hold a solid layer of pigment. The more the surface flexes, the more pastel drops off.

An inexpensive substitute is hardboard with a coating of either artist's rabbit-skin glue, or wall-

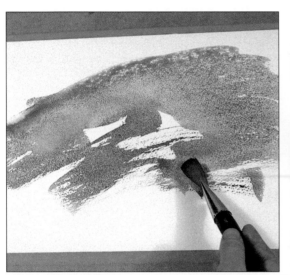

FAR LEFT: *Putting watercolour wash on prepared paper.*

LEFT: *Rubbing fingertips on the wet paint produces a mottled effect.*

BELOW: *The paper has dried to a subtle, smooth texture.*

paper paste mixed with gesso powder, available from the more specialist artist's suppliers. The surface should be finished with sandpaper when dry.

Pastel papers

There are several papers with a medium grain sold specifically for pastel work. These are either tinted in a single colour, or are slightly mottled (I prefer the neutral tones). It is much easier to work on a toned background than a white one, as the light areas will immediately stand out and you can let some of the paper's own colour act as the background tone. When selecting paper, take into account the mood of your subject and choose either a warm or a cool colour to enhance it. The tinted surface is especially useful for outdoor landscape sketching, where you have to work quickly, as the background colour will serve as a basic sky or ground tone.

The disadvantage of pastel paper is its shallow texture. This fills up with pigment very quickly, and it is difficult to put on a second layer which stands out. One feels the pastel sliding over the powdery surface, with no texture left to give any sparkle. When this happens a spray of fixative will restore some of the texture, but it is only of very limited value. Keep the problem in mind when using this paper, and try not to overwork.

RIGHT:
Scene painter's charcoal is lightly rubbed on the paper.

FAR RIGHT: *A light wash of watercolour is put over the charcoal.*

BELOW:
Once dried, the paper has a strong texture and slight tint.

Charcoal papers

These are very lightweight, with a strongly patterned texture. I prefer them for quick sketches rather than finished work, as the pattern can be intrusive and the thinness of the paper causes the pastel to smudge easily.

Watercolour papers

These are tough and hardwearing, and excellent for a pastel painting which is to be heavily built up. You will need the medium or rough surface to hold the pigment, and the paper must be sufficiently thick for its texture not to be rubbed flat by the layers of pastel.

This type of paper can be treated with water-based paint such as gouache, tempera, or acrylic – and, of course, watercolour itself – to give it an interesting ground colour. For my own purposes I find it the most satisfactory paper, and it can take a great deal of punishment and reworking.

Prepared paper

This is watercolour paper which has been stretched and treated – a process done by the artist, not the artist's supplier.

To prepare your paper, firstly soak your watercolour paper for at least 30 minutes in clean, cold water. Heavier papers, such as 300 lb (136 kg) watercolour paper, will need more time. You can test it by checking whether the paper is soft.

Next, remove the paper from the bath; let some of the surface water drain off and place it on a non-porous surface, such as glass, formica or hardboard that has a plastic coating on one side. It is best to hold the paper with two hands from the edges, lowering it so that the middle makes contact with the glass first. Care must be taken to avoid air pockets underneath the paper. Examine the paper from an angle to see if you notice any blisters which will indicate an air pocket. These can be smoothed out with the hand, pushing the blister towards the edge of the paper.

Moisten the brown paper tape and put it all around the edges of the paper, with a half-inch (1.25cm) overlap. This will hold the paper securely as it shrinks and dries taut. The tape should not be removed until the paper is completely dry.

Watercolour paper is left to soak for at least 30 minutes.

Brown paper tape holds the paper taut as it dries.

The finished result.

DRAWING AND PAINTING WITH PASTELS

Now that the paper is stretched you can work on it while it is still damp. You can brush on watercolour, add pastel lightly to the surface and then brush this around with clear water. Ground pastel can be worked into the surface with a brush. You can also spray coloured inks onto the surface, using the same atomizer that you have used to apply fixative. Each of these methods will give you a different background to work with. There is an endless variety of textures and colours you can create and it is great fun to experiment. The reason you must go to all this trouble stretching the watercolour paper is that if you put watercolour paint or other wet media on wet paper, it tends to become wavy as it dries. This, then, is the standard method of stretching and preparing watercolour paper.

ABOVE:
Blue pastel rubbed over the paper with a wash of binder.

LEFT:
A loose textured wash is used to achieve a finished effect.

Flour paper

This is the finest grade of sandpaper, sold for pastel work but exactly the same as that available in small sheets at DIY shops. The only difference is the size; if you want a large sheet, you will have to buy it from the art shop. It is a strange paper to work on, but interesting, as pastel applied to the surface in quantity takes on a rich, painted look. Its disadvantage is that it is difficult to move the pastel, once on, and erasing is almost impossible. It is a good idea to try this paper at least once; I have found people either hate it or love it.

Other supports

Brown wrapping paper is very useful for laying out a large painting, since the sheets are big and inexpensive. Use the dull side, as it will hold the pastels better. I like the colour and texture of this paper, but unfortunately it has a short life, as do all wood pulp papers or cardboards – so it should be used for planning and experimentation only.

Canvas and cotton fabrics, mainly sold for oil painting, can be bought by the metre in the larger artist's suppliers. They can be glued onto hardboard or wood with rabbit-skin glue or thick wallpaper paste, and the textured panels painted with acrylic or gouache, with pastel added as a finishing touch on the rough surface.

You can experiment with any type of paper or board, but when preparing grounds, use water-based paints that have a matt surface, and try to use paper with a rag content or one that is acid-free. Paper with a large wood-pulp content, or ones that have been heavily bleached, will disintegrate with time. The pastel pigments themselves are very permanent. The problem is to find a good, strong support for them and to protect the surface.

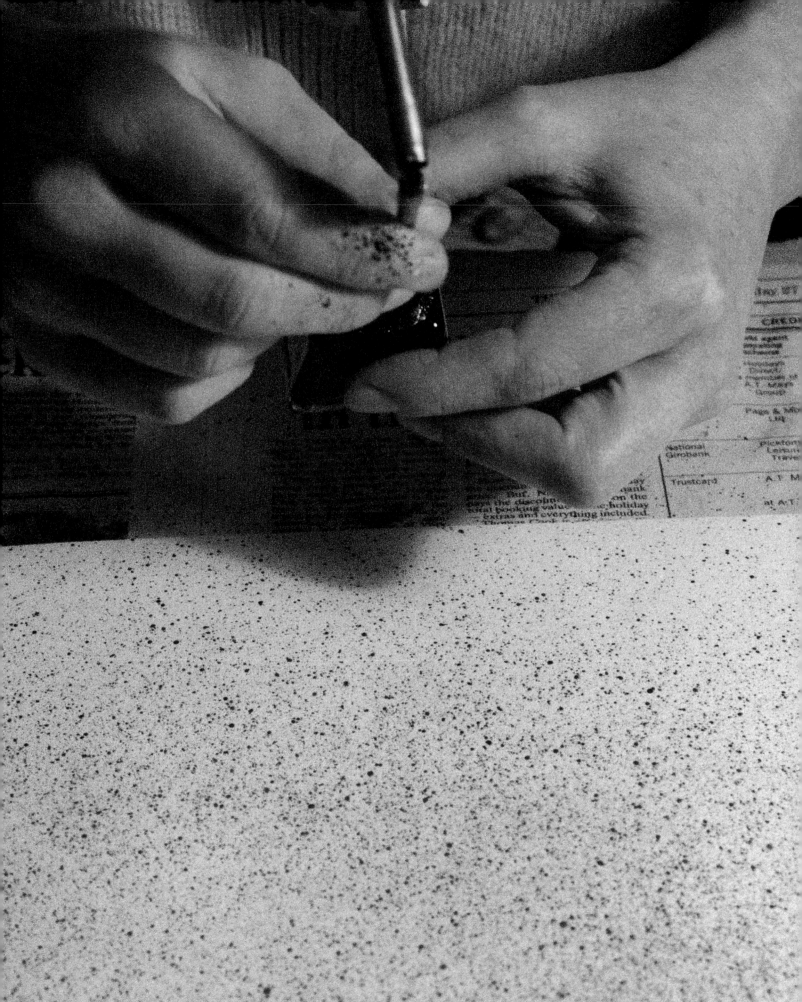

*Small pieces of pastel
can be used to make an
interesting background.*

TECHNIQUES

Because pastels are pigments in stick form, they call for different techniques than those used for paints which are applied with brushes. They should not, however, be held like a pencil or crayon except when you are using them as drawing implements, perhaps making a preliminary outline sketch. They are normally held 'underhand' so that you can either use them on the point or vary the position all the way down to completely flat on the paper. The density of colour and tone is controlled by the amount of pressure on the pastel. With strong pressure you can achieve the density of oil paint, but once you slightly lift the pressure, the character of the line changes completely, and in this way you can move from impasto

to a very thin, dissolving veil of colour. As we have seen, the surface that you work on is of paramount importance, for it will create the texture of the work and affect how much colour can be built up.

When you begin work you face three decisions. First the type of pastel you will use; second the type of paper or board, and third the surface that the support is laid on. The latter can be as important as the support itself, as thin paper can be given a texture by placing it on a rough surface, I frequently tape the paper to my studio wall which gives me additional interest on the surface. This is a technique called frottage, which is similar to brass-rubbing. The paper can be used over wood, corrugated cardboard, canvas – indeed almost anything.

Pastel bits of various colours are ground on a piece of glass.

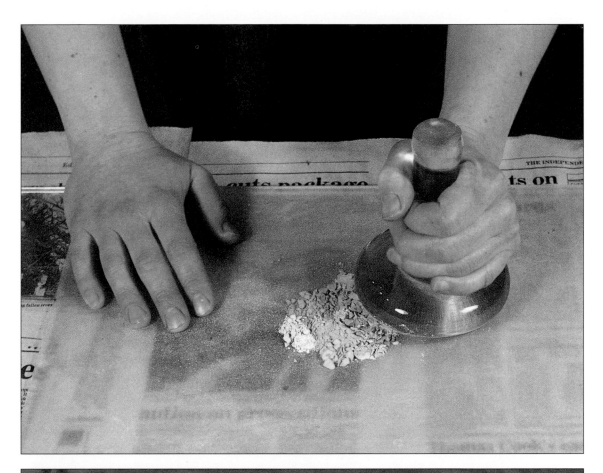

The ground pastel is sprinkled over the paper and brushed into a texture with water.

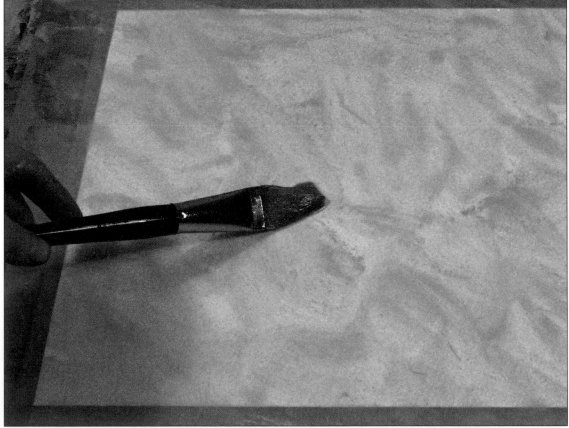

Strokes

It is a good idea to begin by familiarizing yourself with the strengths and weaknesses of what Chardin called his 'magic powder' by making random marks on scrap paper – scrawling, hatching and dabbing until the pastel seems to be an extension of your hand. As you relax, you will soon discover the wonderful facility that the medium bestows. The pastel will seem almost to take on an existence of its own: forming rich fields of colour on smooth surfaces and interesting, broken patterns on textured ones.

There are two ways to apply your strokes. One is by using the pastel in its role as a drawing implement, sketching in the forms of your subject with the fine point or with the sharp edge of a pastel snapped in two. In this case, experiment with the line: controlling the pressure will give either a thick or thin outline. Give the point of your pastel free range in exploring the possibilities of the working surface – draw sensuous, heavy lines and then taper them down to fine ones.

The second way is to use the pastel on its side, texturing with short, sharp strokes and then blending either with the fingers, the side of your hand, a brush or a stick of tightly rolled paper. The broad, lateral stroke is best achieved with broken pieces of pastel, no more than 2in. (5cm.) long. Applying sideways pressure, move the pastel across the paper in broad, rapid strokes. If you want to block in a landscape or a skyscape, for instance, you can cover a large area quite quickly, varying the pressure to produce a greater concentration of pigment for a shadowy land surface and a broken, lighter effect, with more surface area showing, for the sky. The rougher the surface texture the better if you want to emphasize natural effects like a ploughed field or rocky strata.

Layering, which was much favoured by Degas, is probably the most satisfying technique. It involves laying down one layer of colour with the flat side of the pastel, fixing it with a spray and then putting a layer of a different colour on top of it. Two different types of effect are achieved, depending on the way you use the spray fixatives

This is the correct way to hold the pastel for side strokes and for layering.

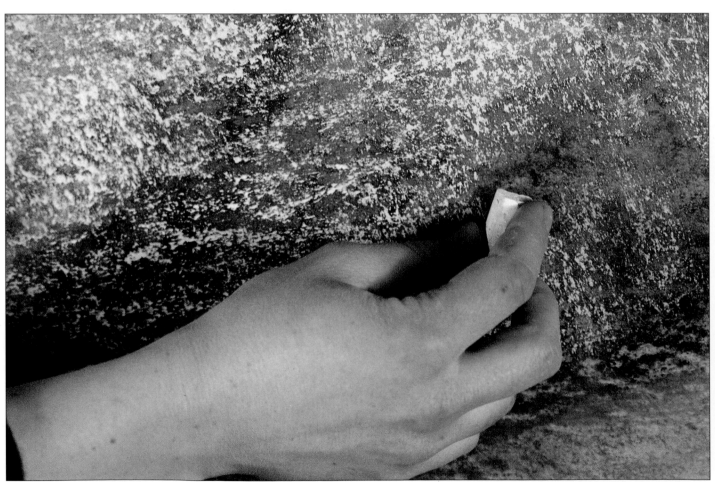

The variation in line is achieved by drawing with the tip of the stick and then the flat.

This pattern is made with the side of the pastel: to make the thin line, the stick is rolled on to the sharp edge which has been formed.

between the layers. The appearance of these layers depends on the type of paper used.

Softening edges is a method of making objects recede into the distance, ideal for clouds or misty, far-off features, while the foreground details are treated with a more 'hard-edged' outline. The same applies in portraiture: the juxtaposition of hard and blurred lines and hatching can provide the essential modelling for the features, with the sharp edges, recessing with the curvature of the head into soft-edged shadow.

Blending, which gives pastel work its sensuous subtlety, can also make it 'sugary' and trite if overdone, so it must be used with discretion. The finger is the easiest blending 'tool', but for detailed work the torchon, a tight roll of paper, is recommended, and for large areas a piece of rag is ideal. A sable brush is useful for softening an image without losing too many of the pastel particles.

Feathering can be a help if you have been over-enthusiastic in blending and your picture has become lifeless. This technique consists of superimposing light strokes of one colour over another so that the one below shows through; very little pressure is needed to create the rather ethereal effect. Particularly exciting areas of colour can be achieved by feathering complementary colours, such as red and green, or yellow and mauve, over one another.

LEFT: *Torn pieces of masking tape form an abstract pattern on corrugated cardboard.*

LEFT: *The side of the pastel has been used to bring out the linear pattern of the surface.*

FAR LEFT: *With the tape removed, additional colour can be put into the shapes to complete the work.*

LEFT: *This simple abstract was done by rubbing with the flat of the pastel on the corrugated surface and then blending the shapes.*

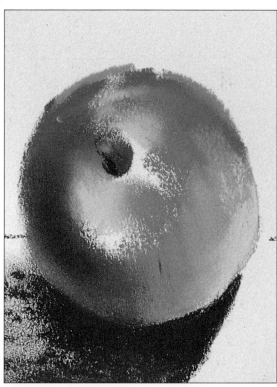

FAR LEFT: *The blocks of colour have been put in without outlining to build a solid form; the strong contrasts help to keep the drawing lively.*

LEFT: *I have blended the edges of the colours with my fingertip and added a dark shadow to give weight and dimension to the fruit.*

BELOW: *The basic method of using blocks of colour and blending edges was followed in this still life.*

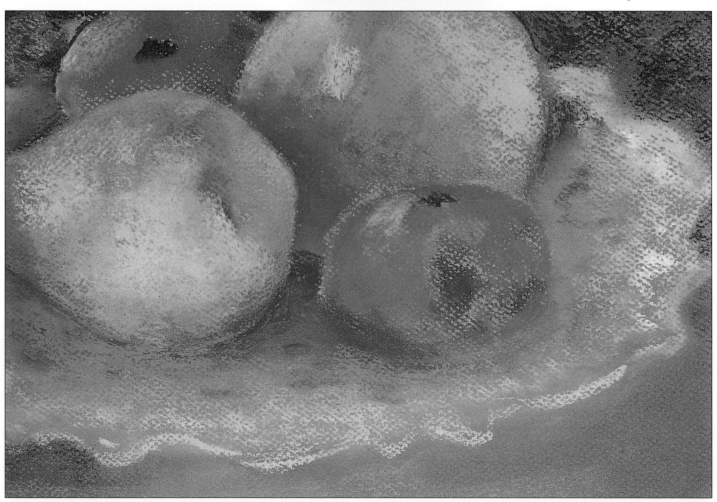

WAYS AND MEANS

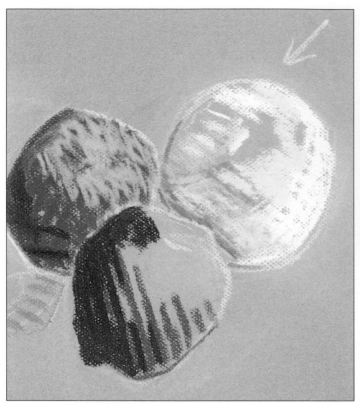

Cross-hatching is a good way of exploiting the vibrancy and versatility of pastel. This is the traditional drawing technique of building tones with lines of different density crossing each other diagonally. The different colours act both independently and in concert to create an illusion of vibrancy and movement.

Scumbling, usually done on tinted pastel paper, is a method of partially covering the background colour so that this comes through to produce an interesting three-dimensional effect. You can build up a background with loose lines, rather like a compressed scrawl, or you can use the side of your pastel to make loose marks which go in several different directions. I usually take a piece of soft tissue and blur parts of the area. More than one colour can be used, as can both the side and point of the pastel.

Pointillism was the method pioneered by Georges Seurat (1859–91), who broke down areas of colour into tiny dots so that the points of colour merge in the viewer's eye into three-dimensional forms. His paintings were in oils, but the effect is much easier to achieve with pastels. It is a good technique to try on flower subjects. Hard pastel is the best to use; either sharpen the sticks or break them to get a sharp corner.

WORKING METHODS

One of the drawbacks of pastel is that it is a remarkably messy medium, at least until you learn to control it. Use plastic bags, where possible, in mixing dry pigments, and try working upright on an easel or tape your paper onto the wall with masking tape. This allows the dust to fall off the surface cleanly.

I prefer working in the perpendicular, both for this reason and because it is important to be able to step back and to see your work from a distance. You are too close to the subject when working on a table or with a board on your lap. If you are putting in a very strong or dark colour and you don't want the dust to fall on the area underneath, you can simply turn the picture upside down, it is perpendicular.

Placing a thick layer of newspaper on the floor underneath the picture gives two advantages. First it enables you to dispose of the dust easily by picking up the paper when you have finished working, and second, if the pastels slip from your grasp, which happens frequently, they won't break easily. Bubble wrap is even better than newspaper for this purpose, if you have any.

ABOVE LEFT: *The outline of the fruit has been drawn using lighter lines in the areas where the daylight is falling.*

ABOVE RIGHT: *The form is built up using dark and light cross-hatching, with the strokes following the shape of the fruit.*

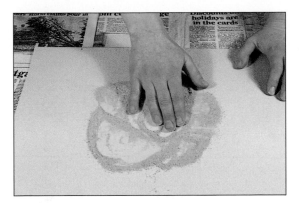

RIGHT: Crushed pastel is rubbed into the surface of the paper to prepare a smooth fine tint.

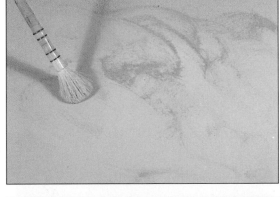

RIGHT: The surface is lightly brushed to spread out the pigment to cover the page.

RIGHT: This texture is the result of working with the paper on a rough surface.

RIGHT: The left side of this paper was sprayed with fixative between layers.

Erasing

The best method is to use ordinary bread, but avoid very stale, hard pieces, as the dryness may scratch the drawing. Bread is the standard 'tool' used by framers for cleaning mount board, as it does not damage the surface of the paper. If the pastel is thick, a single-edged razor blade can be used to scrape off some pigment before erasing.

Conventional rubber erasers flatten the texture of the paper and smear the pastel into the grain instead of gently lifting it off. A kneaded or putty eraser can be useful, however, for lightening a small area to obtain a highlight. You press the eraser on the spot and lift it off without rubbing; the pastels adhere to the sticky surface.

Fixing

This has been a source of great concern to many pastel artists, as fixative does change the colours to some extent. Generally it is best to fix as little as possible, and protect your work by glazing and framing. Even so, there is a danger of the pigment falling off your painting and spoiling the mount, which can be prevented by a light spray of fixative beforehand.

There are many brands of good fixative available in aerosol cans, and some are now produced with ozone-friendly propellants. When you spray be careful not to saturate the drawing.

The spray affects the lighter colours most, as the whites are 'pushed back' and blend with the colours underneath, depending on the amount of spray used. I sometimes spray and then pick up the light tones with additional pastel when necessary.

Fixing can, of course, form a vital element of the painting, as in the technique of layering. Degas sprayed his paintings between successive layers to hold the colour underneath, thus ensuring that the new layer was not contaminated by mixing.

It is also possible to increase the adhesive quality of the pastel by spraying the fixative on the back of the paper – provided you are not working on a very thick board or watercolour paper. The fixative will soak through and hold the pigment without damaging the surface. It is important to remember that all fixatives should be used in well-ventilated rooms.

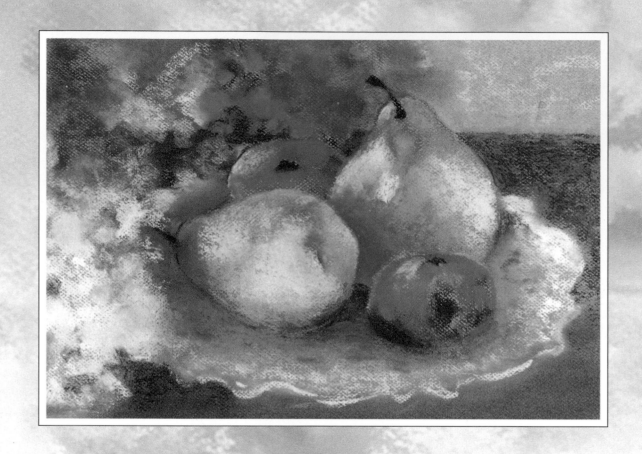

THREE

STILL LIFE

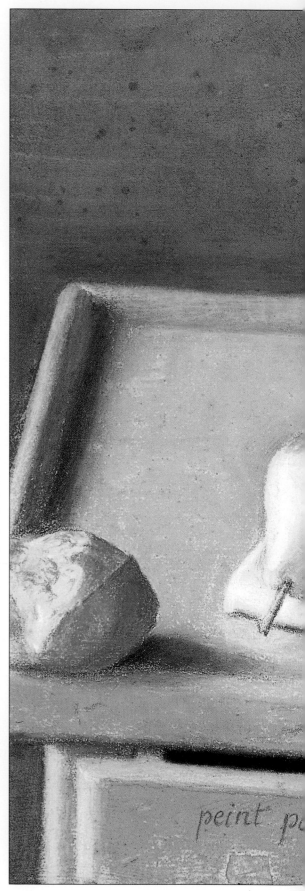

RIGHT: JEAN-ETIENNE
LIOTARD, 1702–89, *Still
Life with Fruit, Roll and
Knife*, 13 × 14½in (33
× 36.8cm), Museum of
Art and History, Geneva

*In a letter to his son of
24 September, 1782,
Liotard described the
satisfaction this work
gave him. 'When I was
only 30, I could not have
done them so well,
having more skill now
than I had then.' It is
worked on vellum, and is
signed with his name
and his age – 80 years.
He has distorted the
perspective of the table to
give us a clearer view of
the objects, a device
Cézanne was to use for
his still lifes a century
later.*

The Greeks and Romans were the first to
find merit in recording the minutiae of
their daily lives. One of my most fascin-
ating discoveries when living in Rome
was the House of Livia, almost buried by the
massive foundations of the ruined palaces of the
later Caesars. The whole of the dining room of
this surprisingly small building is frescoed with
wonderfully realistic green apples.

The eruption of Vesuvius which buried the
cities of Pompeii and Herculaneum preserved
other examples of the genre we now call still life.
Numerous frescoes from the houses of well-to-do
citizens can be seen in the Naples Museum, while
in the eastern slums of the city there is a less-
known archaeological site with perhaps the finest
examples of all. An opulent villa called Oplontis,
which was probably built for Nero's empress,
Poppaea, is frescoed with *trompe l'oeil* baskets of
figs, beautifully painted glass bowls of pome-
granates and bunches of luscious muscat grapes.

During the Middle Ages, when minds were
concentrated on the divine order, there was no
place for still life as such, but artists did not
ignore the natural world, and the humble flowers
of the wood and hedgerow decorated the margins
of the illuminated prayer books, particularly
those of late medieval Burgundy. This charming
realism was continued in later centuries by the
Dutch, the heirs of the Burgundians in the Low
Countries. By this time working, not for the
Church but for a wealthy merchant class, these
artists raised the still life to a distinguished art
form in its own right, delighting in elaborate and
carefully arranged studies of floral sprays and fruit,
set in gleaming crystal or pewter.

Still life remained a popular subject from then
on, with artists of later periods using arrangements
of static objects as a springboard for the develop-
ment of theories about the way we see and under-
stand images. Chardin, for example, made a
patient study of light and form in this way, while
in the next century Liotard suspended the laws of
perspective to give us a clearer view of the subject.
Paul Cézanne (1839–1906), the great theorist of
the still life, was influenced by the Impressionists'
theories of colour and light, but took his own
experimentation with the objects of the table top
much further into an analysis of colour, tone and
form that had a lasting impact on the direction
of modern art.

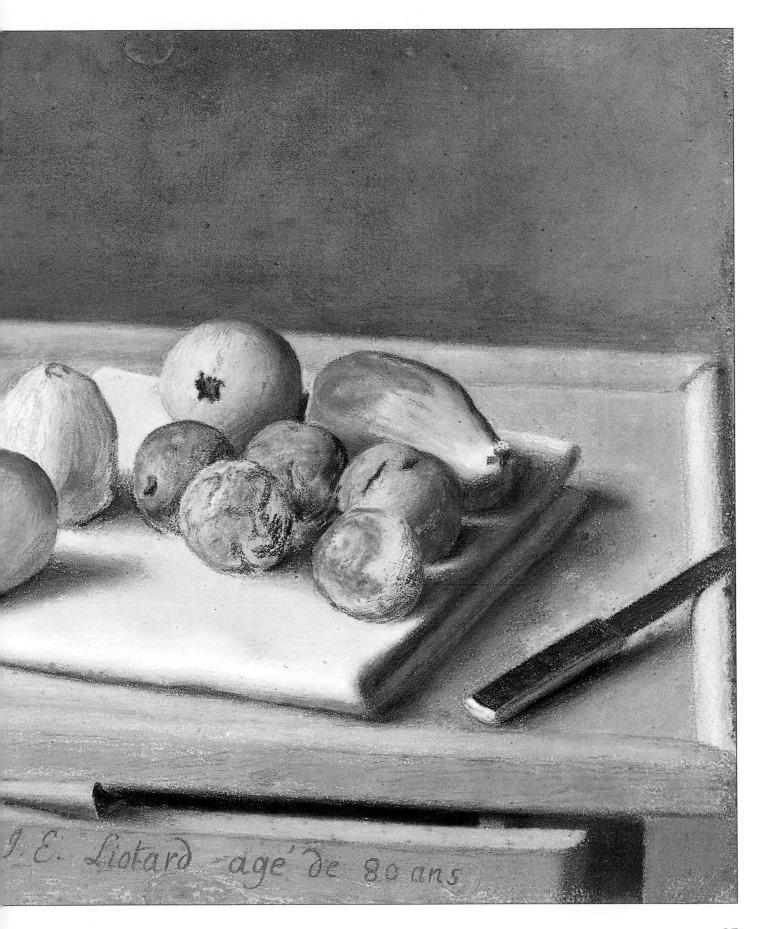

I. E. Liotard =agé de 80 ans

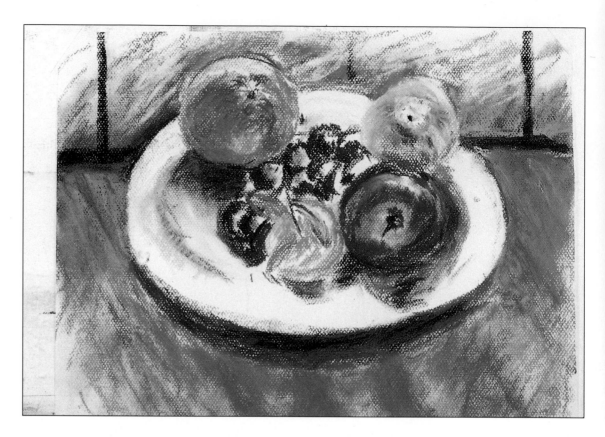

STARTING A STILL LIFE

We cannot all aim as high as this, but for any art student the lessons learned from the still life serve as a working guide to other, more complex subjects. It also provides the perfect opportunity to experiment with the medium. You can select the objects from your own kitchen or dining room, set them up however you choose, and work in peace. Both Chardin and Liotard towards the end of their long working lives chose to use pastel exclusively for their still lifes, and there could be no higher recommendation for anyone new to it.

How do you go about selecting and arranging a still life? First, look around your home and see if there is a natural still life subject there. A corner of the kitchen; some bread, vegetables or crockery remaining from a meal; the arrangements on your mantelpiece; your house plants – all these can be used. Ready made subjects such as these are sometimes called 'found' groups, and it is always worth exploring their possibilities, as they have the appeal of familiarity. You may, however, wish to 'build' a still life, in which case you will need to look for a certain logic within your subject.

The size relationship of the shapes and their textures are of primary importance. Choose one object to be the centre of interest. It does not necessarily have to be the largest; it may have a very strong colour or a very definite tone to make it stand out. Try to choose a variety of different textures also. It is very interesting to use a glass or metal object, say a bottle or a vase, combined with softer, heavily textured objects, such as fruit or fabrics.

The placing of the still life is equally crucial, and makes an interesting exercise. Using illumination from a window, for instance, is an excellent way of studying directed light and will help you when you go outside to paint landscape. You could also try placing the objects directly in the path of the light, so that they are silhouetted against it and throw strong shadows which can form a powerful composition. The other consideration is the angle at which you will be looking at the still life. Will you be looking down on it, perhaps on a low table or the floor, or will it be at eye level? To begin with you may want to restrict yourself to a very simple background, so that you can concentrate on the balance of shapes. Later on you can add some interesting fabrics and textures or a detail of the room.

STILL LIFE
WITH PEARS

Stage 1: I began with a simple drawing of the objects and laid in the darkest and lightest tones to try to obtain a balance in the composition. Only when I was satisfied with the arrangement of lights and darks did I begin to put in the middle tones and start the actual finishing. I have now put in darker colours, dark green and dark brown, in the central pear, and have very gently, with a soft pastel, overlaid this with a lighter yellow.

It is extremely important to allow the contrast to remain pronounced at this stage. If you try to unify and finish it too much too early on you will simply deaden the effect. Keep the contrast and the colours as bright as possible. Don't worry if the effect looks rather garish and hard, as you can pull the tones together and modify them with pastel very easily in the final stage. It is much more difficult to freshen the composition once you have lost the contrast.

Stage 2: I am now at the half-way point, having put in a light blue background and the dark tone of the table. I am concentrating now on getting the table and flowers to frame the pears on the plate. I will work for quite a time adjusting the tones, darkening the areas underneath the fruit to give them weight and make them look three dimensional. I have sketched in the flowers roughly and then blended the pastel to make them less distinct from the centre of interest. The reason for this is to avoid the over-busy effect a picture can have when everything in the composition has equal prominence. This is a basic rule for all compositions, whatever the subject: the centre of interest must take precedence, with the other objects playing a supporting role.

Stage 3: I have blended the tones on the fruit with a blending stick and my finger and then laid in the highlights. Before doing this I applied a light spray of fixative so that the highlight colours would sit on top of those underneath rather than mixing with them.

BELOW: *Stage one.*

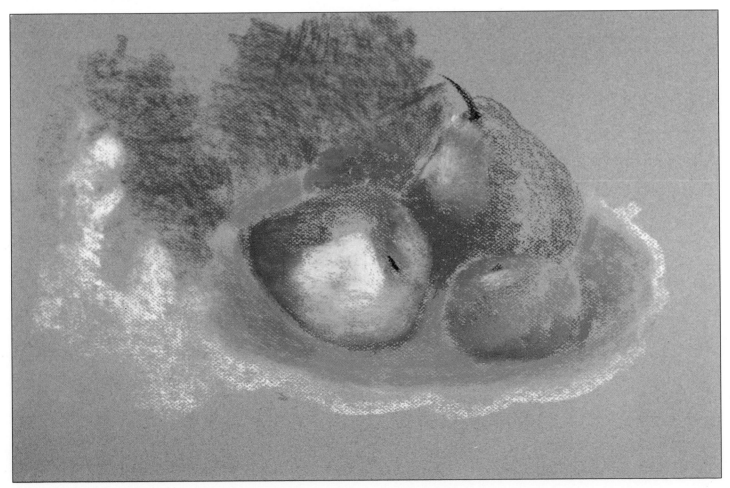

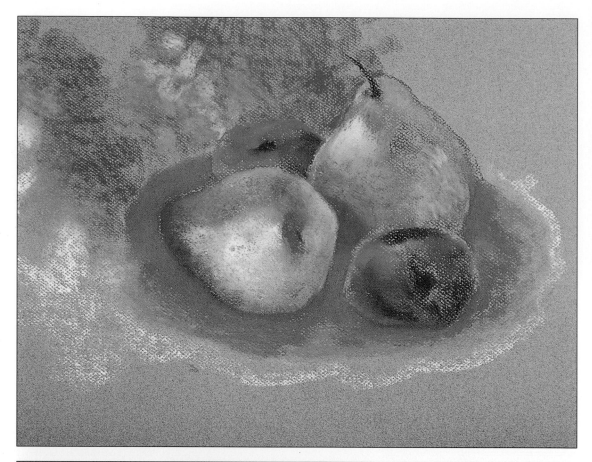

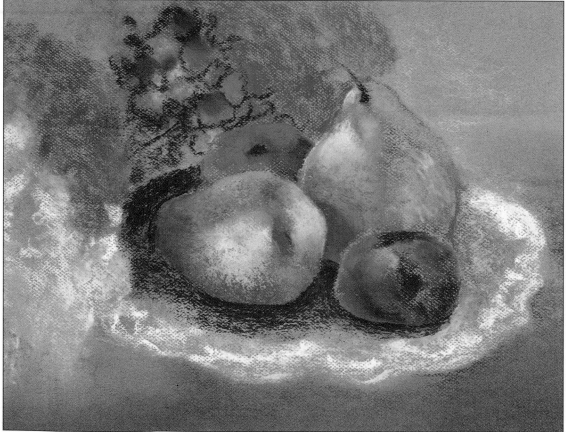

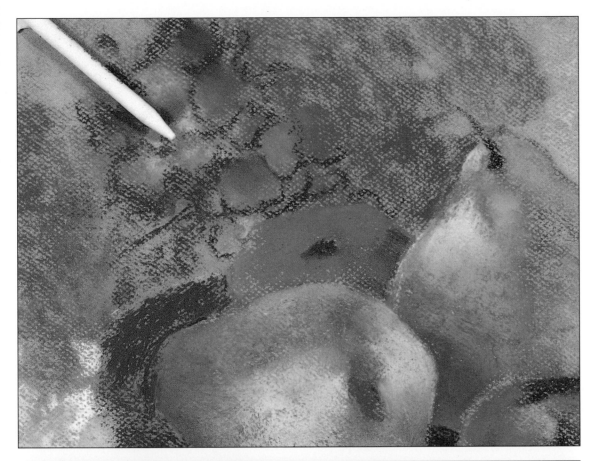

LEFT: *Using a blending stick for fine detail.*

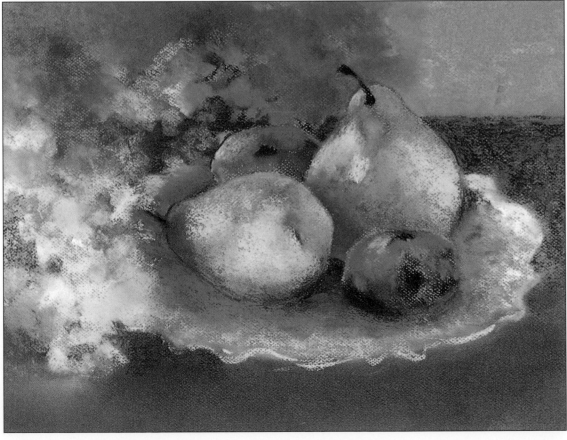

LEFT: *Completed painting.*

RED APPLES

I had set up this group the day before. When I came into the studio in the morning it was side lit from the window, and had a very different quality from the still life that I had been doing the day before under artificial light. I thus decided to try a very quick sketch to capture the subtle light before it changed.

Stage 1: I used a deep indigo for the area of shadow on the apples to give them a feeling of weight, and then lightly layered alizarin crimson over it, allowing the two colours to mix to give the very dark, almost mauve colour of the shadow. I drew in the turnip lightly to establish its place in the composition, and then increased the tones so that the contrast is very distinct. The jagged line between the tones provides a bit of tension, as it contrasts with the curves of the fruit.

BELOW: *Stage one.*

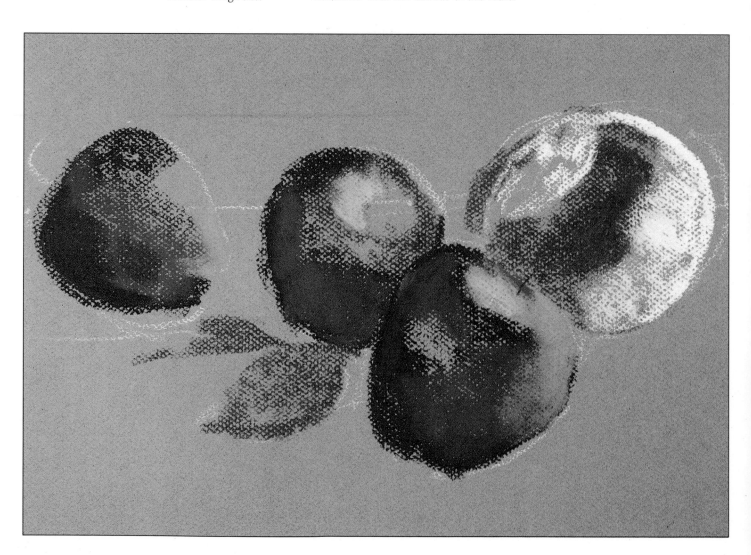

Stage 2: For the table I have laid in a very light blue tone but am making considerable use of the colour of the paper by only partially covering it. This is intended to remain quite a sketchy pastel, and I am deliberately avoiding overworking it. When you are working with natural light from one direction, be careful not to work too long in any one day. As the light changes the colours and tones of your group change too. You will assume you have made mistakes and try to correct for the change in light, which can get you in a real muddle. If you cannot finish your pastel in one sitting, return to it on the following day at the same time.

BELOW: *Stage two.*

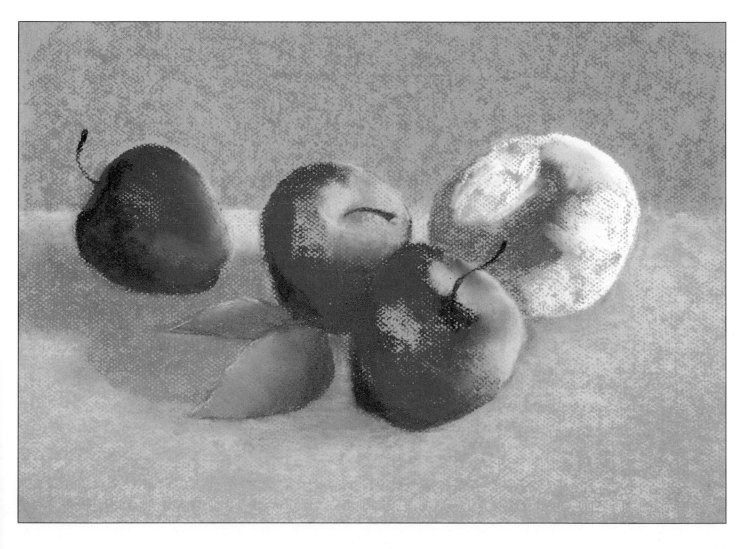

STILL LIFE FROM THE KITCHEN

Stage 1: I am working on tinted pastel paper, and have drawn in the objects with a hard umber pastel. I have sketched in each object completely, superimposing one over the other so that I can be sure that I am allowing enough space between them. If you do not draw them in three-dimensionally you may find in the finished drawing they are placed partially inside one another, one of the commonest mistakes in still lifes.

Stage 2: I have begun to put in the colour of the objects, paying particular attention to the background around the colander. Since this is a light object, it will depend on the area around it to give it shape. I have chosen this and the black cast-iron frying pan because I want a high-contrast effect, and I have placed the celery in the pan to produce a strong diagonal to help the composition.

Stage 3: I have now stepped up all the tones and colours. I have imagined a light coming from the right side so that I can put a strong shadow on the left side of the colander, increasing the three-dimensional illusion, and have put shadows under all the objects to make them look solid. The basic colour of the colander is that of the tinted paper coming through, but by drawing around it and shading it I have defined its shape and form.

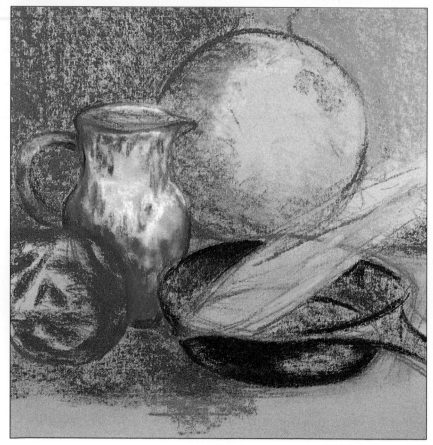

UPPER RIGHT: *Stage one.*

RIGHT: *Stage two.*

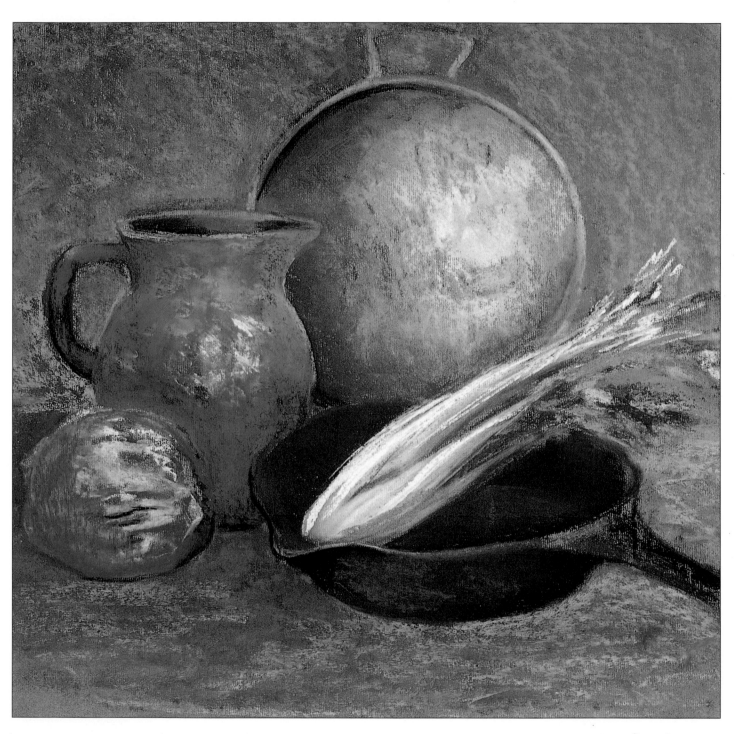

ABOVE: *Stage three*.

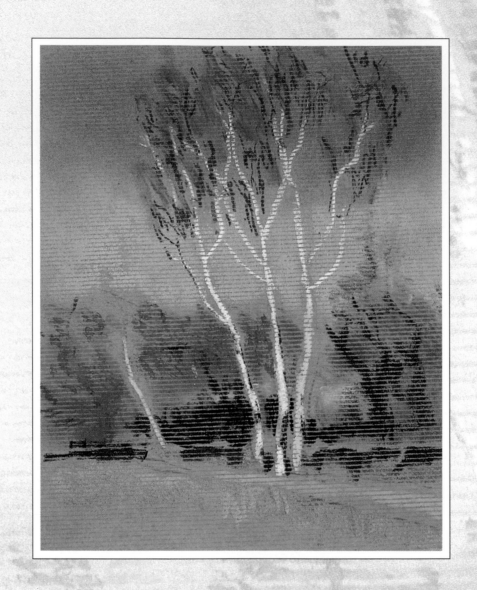

FOUR
LANDSCAPE

RIGHT: CAMILLE
PISSARRO, 1830–1903,
*The Pond at
Montfoucault, Autumn,*
9¾ × 13⅞in (24.3 ×
24.7 cm), Ashmolean
Museum, Oxford
*In the briefest of
sketches, made on tinted
paper with soft pastel,
Pissarro has captured
the mood and colour of
autumn. The cool shades
on the water have been
blended to contrast with
the rough textures of the
trees and foliage.*

lthough Renaissance artists often included lovely landscape backgrounds in their religious paintings, and even some medieval manuscripts included pastoral scenes, landscape was not in itself thought a suitable painting subject for art.

Paintings were commissioned by the Church, and landscape, if it was considered at all, was seen as an enclosed garden of earthly delights, reflecting a divine order.

It was only with the rise of Protestantism in the seventeenth century that artists, and particularly the Dutch, began to look at the world in an objective way. They started to paint, not only still life and flowers, but also their surrounding countryside and the dramatic changes in the sea and sky which enclosed their flat landscape. The beautiful brush drawings of windswept landscapes by Rembrandt (1606–96) and the canvases of heathland under great silvery skies by Jacob van Ruisdael (1628–82), one of the greatest of the Dutch landscape painters, typify this new ethos concentrating on the physical world.

It was not until considerably later, however, that similar ideas took hold in Britain, where painters such as John Constable (1776–1837), John Sell Cotman (1782–1842) and John Crome (1786–1821) began to produce romantic yet realistic interpretations of their own humble cottages, mills and fields.

It was only at the turn of the nineteenth century that British landscape painters acquired a European reputation. The freely rendered seascapes of Richard Parkes Bonington (1801–28) had considerable influence on the French Romantics, but the most important figure was the great J. M. W. Turner (1775–1851), whose revolutionary landscapes are still revered by artists of all persuasions and nationalities today.

Turner grew up in London's dockland, and the tall sailing ships and the elements on which they depended – sea and sky – grew to be major themes in his work. In the latter part of his career, sky, sea and land merge into great abstracts of energy and light.

Although Turner did not use pastels, the pictorial ideas incorporated in them form the starting point for most of the landscapes shown in this chapter.

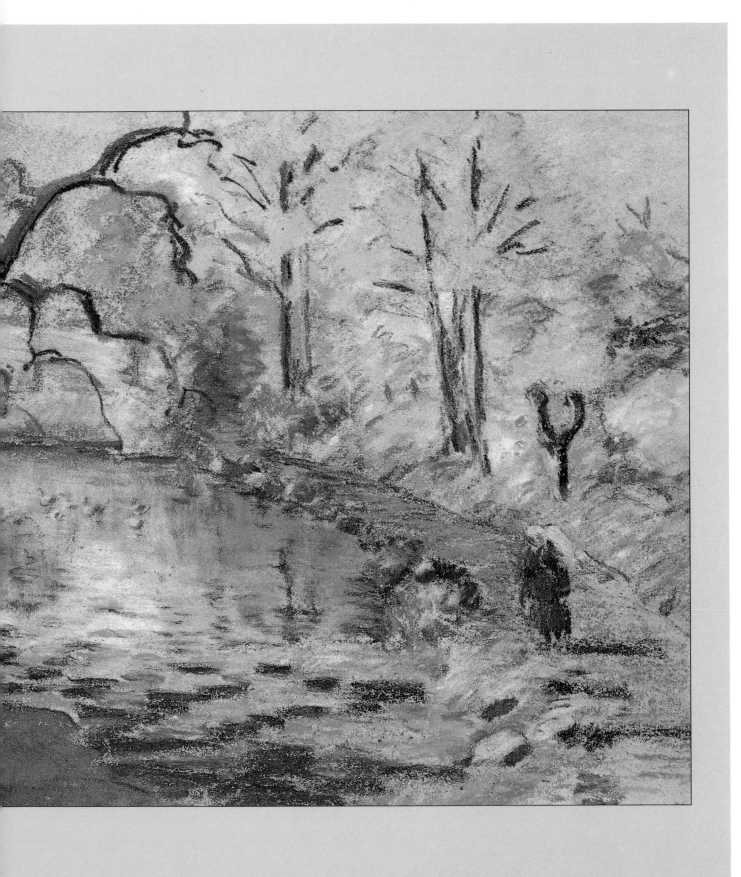

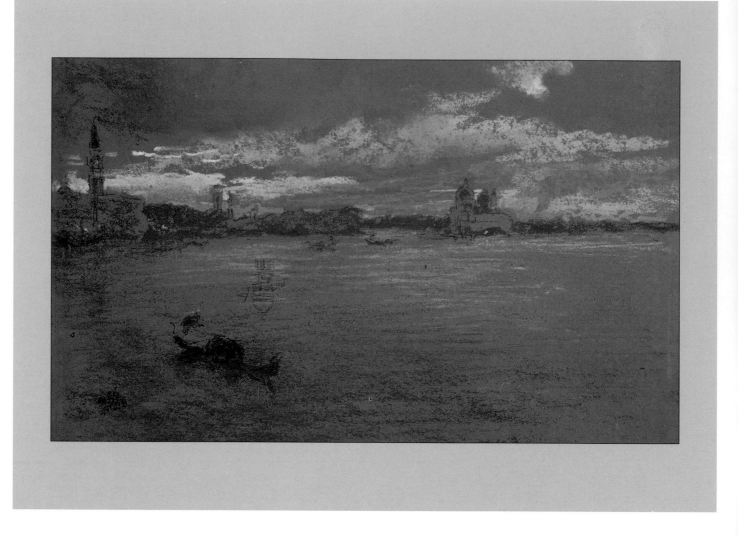

ABOVE: JAMES ABBOT
MCNEILL WHISTLER,
1834–1903, *Stormy
Sunset, Venice*, 7¼ ×
11⅛in (18.4 ×
28.4cm), Fogg Art
Museum, Harvard
University

*The colours were
intended to catch the
mood of Venice, and the
buildings are merely
indicated with a few
strokes of the pastel. The
support is brown paper,
which has been allowed*
*to show through the
water to suggest a
reflection of the pinks of
the sky.*

WORKING OUTDOORS

Turner and Constable knew that nothing in nature is static. The seasons change the colours and forms, and the weather changes the light as you work. Pastel, like watercolour, is well suited to capturing these transient and elusive qualities, and has two additional advantages; the rich colour and the convenience of using a dry medium.

Not all landscapes are drawn or painted on the spot, but working in the open air from nature is the most direct method. The first step is to organize the expedition, so I will make a few practical suggestions. I have always found it wise to take a small camping stool with me. It is almost inevitable that you will not find a place to sit at the best view, and sitting on the ground is not usually a good idea as it can drastically limit your viewpoint. A pad of paper is useful, as it provides a stiff surface, but an alternative is a small board of some sort, with clips or tape to hold your paper. Tinted pastel paper, cardboard or flour paper are good for outdoor work, since the time you will have is fairly limited and you can incorporate the colour of your support into your composition. Remember to protect your pastels in transit, as they are extremely delicate, and bring along fixative spray and tracing paper to put between the drawings to keep them from smearing and rubbing together. A damp rag will come in handy to clean your hands after you have finished your work – this can be kept in a plastic bag.

How do you choose a subject? The first requirement is to have the basis for a good composition, and this depends on making a clear decision about what is going to be the centre of interest, or focal point. It can be a house, or a copse of trees or a dramatic cloud effect. This centre of interest must be placed on the page carefully and not put directly in the middle, which will make a static composition.

The placing of the horizon is important also. There is no reason why the horizon line has to be in a fixed place in all work. Try moving it two-thirds of the way up the page, which will give you a different perspective and plenty of room for the elements on the land, and then try a study with the horizon one-third up. This will create a sky-scape effect and give you a marvellous chance to exploit a dramatic cloud composition. The only place you should not put the horizon is directly in the middle of the page, as this tends to cut the picture into two halves and makes for a dull composition. Placing should be off-centre.

There are few subjects more complicated and elusive than landscape, and you are faced with the problem of making a certain order and pattern out of a vast array of different elements. A very useful tool is an artificial window made out of a piece of stiff card, which acts like the viewfinder of a camera. It need be no larger than about 6 × 8in (15 × 20cm). Hold it at arm's length or closer, and use it to isolate various aspects of the view so that you can choose a satisfactory composition. Once you have selected a subject which is simple enough, with clear shapes, start your drawing, using a light-coloured piece of pastel. Pencil is not advisable, since it will show through the drawing, but you can use a light piece of charcoal stick if you prefer.

Draw in the basic shapes, and also make an immediate note of the direction of the light falling on the landscape – I usually put a tiny arrow on the page to indicate this. It is extremely important, because by the time you have finished your drawing the shadows will have moved, so you need to establish their direction immediately, and draw them in as soon as you have made your initial sketch.

The colour you use for the shadows will depend very much upon the objects in the landscape. The Impressionists liked to use blue or mauves in their shadow areas, giving the feeling of coolness. If you are doing the preliminary sketch with charcoal, some cross-hatching can be used in the shadows. The next stage is to add the middle tones, and the highlights are put in at the end to show the light falling on the landscape.

Avoid putting too much detail or bright colour in the background, as this is usually less distinct, and cooler in colour. The effect of distance is easily achieved with pastel, by drawing it in a light, sketchy way, as Whistler did in his *Sunset in Venice*, where the buildings in the background are indicated by just a few strokes. If he had treated them in more detail they would have appeared in sharp focus and have come forward to the front of the picture. More detail is used in the foreground gondola, even where we can see the shadow it casts on the water. This increases the illusion of the light coming across the water at a low angle from the setting sun.

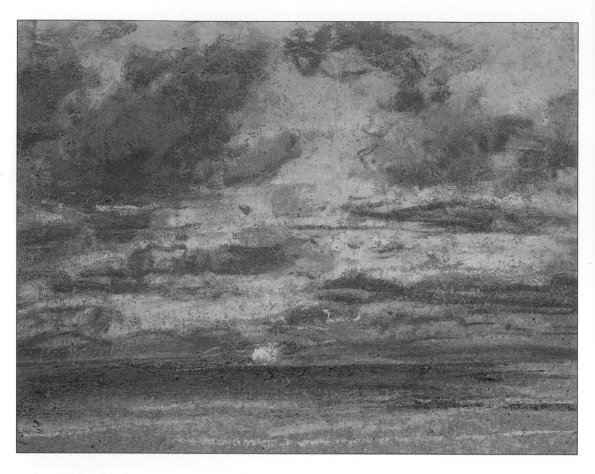

This work, done on a tinted surface, probably card, with soft pastel, anticipated the Impressionists by nearly 20 years. Boudin was one of the first of the plein-air (outdoor) painters and did several hundred pastel studies. In the margin of each is the date, the time and notes of the strength and direction of the wind. Charles Baudelaire, who saw this study in the Salon of 1859, said: 'With one hand covering the caption, you could guess the season, the time of day and the wind. I am not exaggerating. In the end all those clouds with their fantastic, luminous shapes, those confused shadows, those green and pink immensities hanging in the sky piled one on top of another . . . all those depths and splendours, all this went straight to my head . . .'

WORKING INDOORS

Since not everyone has the opportunity to sketch landscape outside, it is important to devise ways of working in your own home. Large, finished pictures in any case have to be done indoors. Even if you do have access to the countryside, a good way of building up your skill is to work at home making studies from the work of the masters or using photographs as a basis for compositions.

Copying the work of earlier painters was once an essential part of an artist's discipline, and it is an excellent way of learning. The paintings of Vincent Van Gogh (1853–90) are particularly useful for making studies in pastel. Although he seldom used the medium himself, the almost flat areas of brilliant colour which he used together with line in his oil paintings make a transition into other media quite straightforward. Van Gogh was a great master of landscape composition as well as being a brilliant colourist, and much is to be learned from studying his work.

The other method of working in your home on landscapes is to use photographs from newspapers or magazines. I prefer black-and-white photographs because they show the composition broken down into simple tones and give me better scope for my imagination when I translate it into colour. If you use a full-colour photograph there is always a danger that your pastel will become a slavish copy. A good trick is to put a piece of tracing paper over the photograph and trace out the basic shapes, both the elements of the landscape itself and the formation and direction of the clouds. Lightly indicate the dark and medium tones by cross-hatching or shading with a soft pencil. Once you have done this, remove the tracing. You should now have a schematic plan of the composition which you can either transfer onto paper using a piece of carbon paper, or re-draw freehand.

The advantage of the tracing is that you will be seeing the composition in a very simplified form. The fact that you must provide the colours yourself helps you develop your visual memory – you will have to try to recall the colours of a tree, or a field or sky, perhaps at sunset. Over a period of time, and with practice, you will build up a storehouse of information on the colours of objects, which you can check when you go outside.

LANDSCAPE

This painting, done with soft pastel on heavy watercolour paper, was worked on in the studio from a quick sketch and a black-and-white photograph, both made on site. I made a tracing of the photograph, as explained on page 118, to give me a clear idea of the cloud structure. It was a picture that took quite a bit of time and work, and because of its size and the complexity of the technique it would have been impossible to complete outdoors.

This was done in soft pastel on cardboard, and worked in the studio from sketch and a photograph, as in the previous example. The effect relies a good deal on the unusual surface I have chosen. I am always on the look-out for new supports, and have found cardboard quite useful, although it does not have the lifespan of rag watercolour paper.

Stage 1: I have begun by laying in the basic shapes and colours, giving a clear idea of the direction of the clouds.

Stage 2: The next step was to blend the clouds lightly with a soft tissue. I have rubbed the field with the side of my hand, thus pushing the pastel into a strong dark mass which gives the appearance of solid ground.

Stage 3: After the blending I applied a strong fixative spray, and with the first layer held back with the fix, I have drawn over it from the bottom up with a light viridian and ivory.

Stage 4: These soft pastels will begin to mix with a dark background, and the surface relief of the cardboard will start to form a pattern. By using a very light touch one can gradually pull out the pattern of the paper, which in this case is similar to a type of cumulus cloud. Not all boards will have this type of surface but it is worthwhile checking by gently rubbing a soft pastel over the surface, which will bring up the pattern. I have continued to spray between layers, and then glided over the surface with the flat side of the softest pastel.

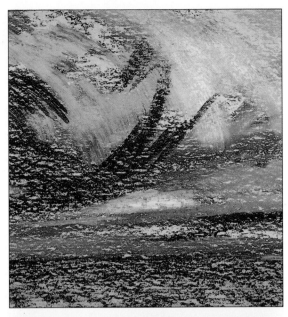

LEFT: *Stage one.*

LEFT: *Stage two.*

LEFT: *Stage three.*

RIGHT: *Stage four.*

RIGHT: *Spraying
fixative
between layers.*

DRAWING AND PAINTING WITH PASTELS

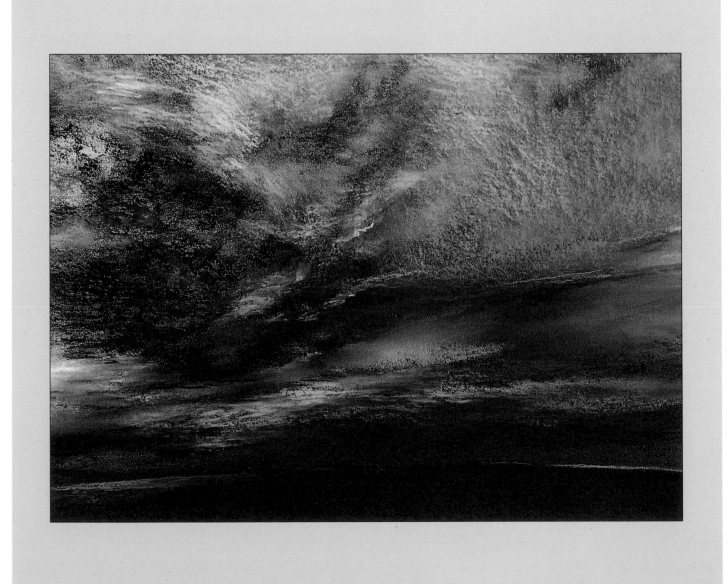

LANDSCAPE

The basic composition is a straight horizon with the clouds moving across in a diagonal and being lifted up over this plane. The storm was lifting and the clouds were just catching the afternoon sun, with the sky quite dark from the lateness of the afternoon and the storm.

Had I been doing this completely on site I would have chosen a dark-tinted pastel paper, but since I am working in the studio I have chosen a watercolour paper because it will give me the necessary strength and texture for layering.

Stage 1: I have begun by placing the horizon line and then lightly sketched in the direction of the clouds, after which I have worked on the background with indigo and a bit of charcoal to stain and tone the paper. I have then increased the indigo in the dark areas and then built up the clouds with yellow ochre for the medium tone and lemon yellow for the highlights. I have also added a small amount of alizarin crimson, which will serve as the warmer tone.

Stage 2: Basically it is now a matter of lightly blending the colours with a soft tissue and the side of my hand in certain areas, leaving others open. Change the tissue when necessary during the blending process so that you don't mix the colours too much; there is always the danger of the whole thing becoming muddy.

Stage 3: In order to get a contrast of tones and textures, I have blended the dark tones to make smooth areas which will recede in the distance. The light clouds are left heavily textured to help bring them forward, creating depth in the picture plane.

Stage 4: Now I give the area a good fixative spray to hold the layer back so that when the next is put on the colours will not blend together. I have used a light turquoise in some of the sky area instead of the conventional blue to make the composition cooler and to contrast sharply with the pinks. Basically the technique involves working for quite a length of time, spraying between layers, building up the effect and moving the clouds in more than one direction.

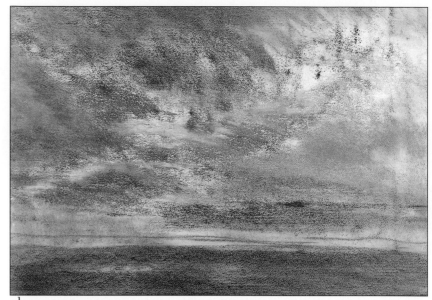

1

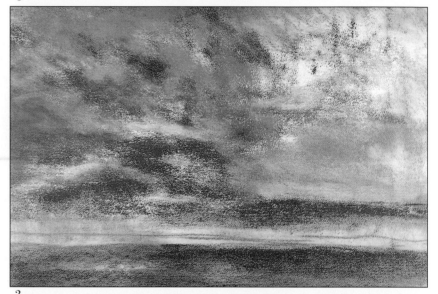

2

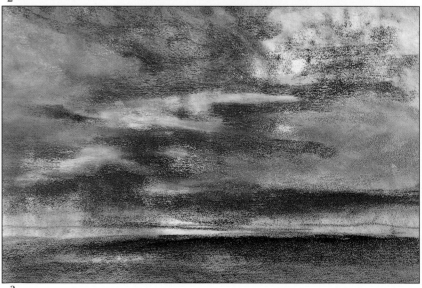

3

56

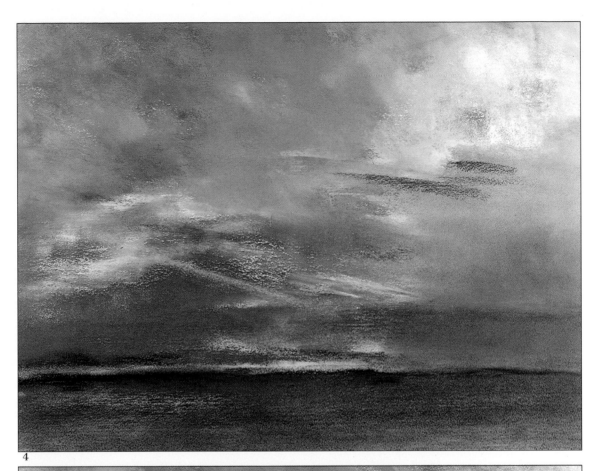

4

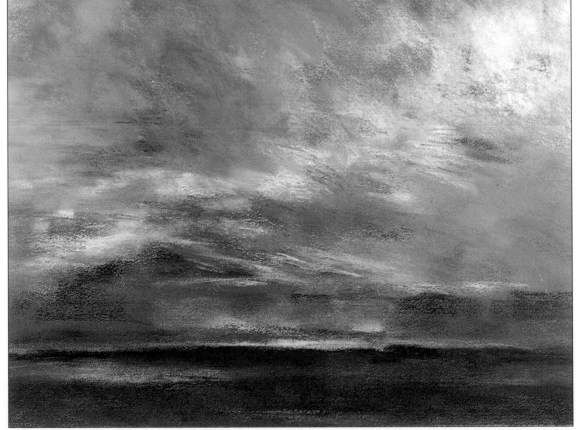

RIGHT: *Finished painting. Dimensions $30^{3}/_{10} \times 44in$ (77 × 112cm).*

CLOUDSCAPE

For this painting I used soft pastel on buff paper, which is similar to vellum, with a soft, velvety texture. I fixed the paper to the studio wall with masking tape – the rough surface of the wall behind the paper prevents the pastel from becoming too smooth.

The cloud was drawn with indigo, and the light area on the left side was achieved by very lightly working over this with white and yellow, using the barest pressure on the side of the pastel. The colours blend naturally with the dark shade below, forming a thin cloud in mixed white and blue, while in some areas the yellow has picked up the blue, making a pale green. I did no rubbing or blending, either with my hand or a tissue; the soft vaporous effect comes entirely from the way the colours just barely blend. Since in this case I wanted the layers to mix, I used no fixative.

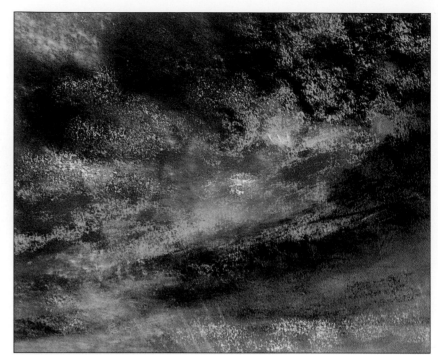

ABOVE RIGHT: *Detail.*

RIGHT: *Moorland cloudscape.*

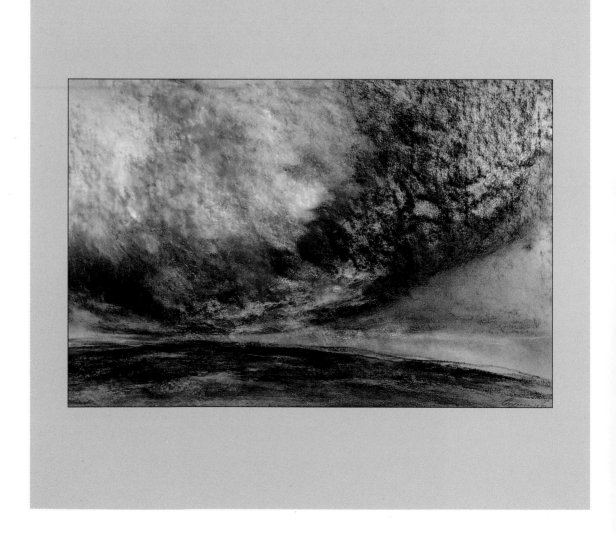

DRAWING AND PAINTING WITH PASTELS

CHERRY TREE
AFTER VAN GOGH

This little exercise, done in hard and soft pastel on flour paper, uses a Van Gogh oil painting as an example of how you can study composition and colour by copying the work of a master. Hard pastel is easier to use on this surface than soft.

Stage 1: I have drawn the same basic shapes as those in Van Gogh's painting, and you can see how he picked out the vital elements to make an extremely strong design. Unlike in the oil painting, however, I have used short strokes to build up the forms. Because of the rough surface of this paper it is impossible to blend the tones, and these will give me a modulated colour.

Stage 2: I have now added more detail and strengthened the dark tones. Because it is impossible to erase satisfactorily, I want to be sure that everything is in the proper position before I apply the final strong colours.

Stage 3: The final step was to put in the light blossoms and complete the drawing of the tree. I have also made adjustments to darken some of the details and pull the composition together.

BELOW LEFT: *Stage one.*

UPPER RIGHT: *Stage two.*

LOWER RIGHT: *Stage three. Dimensions 22 × 29½in (55 × 75cm).*

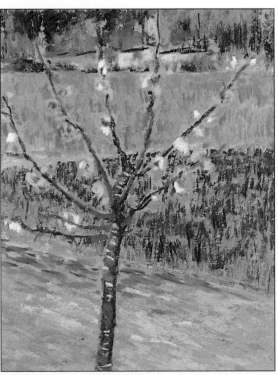

Silver birches, Hampstead Heath

This was done in a pastel sketch book, using soft and hard pastel. It was a very sunny day in early spring, with the light catching the birches. I walked around to find a position where my view would be of the path intersecting the base of the trees, giving me a strong, simple composition to work with.

Stage 1: I have lightly drawn in the bases of the trees with the tip end of the pastel and laid in the background in simple, broad strokes. For the sky I have used two colours, taking a little poetic licence by putting in a darker blue at the top because I wanted to show up the delicate, light branches of the trees. These would be lost against a light sky.

Stage 2: I have slightly blended the colours in the sky and, having established this base to work on, have extended the drawings of the white trees upwards into the sky. It was necessary to put the sky colour in first and draw the delicate lines of the trees on top of it. I would normally have sprayed the sky area with fixative first, but I had unfortunately forgotten to bring it with me, so what I did was to use the edge of a very soft pastel, barely touching in the branches without rubbing.

Stage 3: I have increased the tones in the background hedges and trees and worked on the detail of the twigs at the top of the trees with a dark brown pastel pencil. I have smudged these lines slightly to make them less distinct so that they recede into the distance.

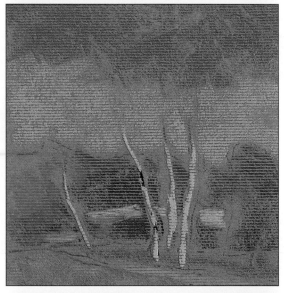

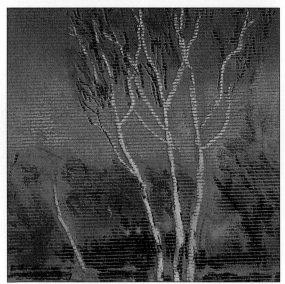

UPPER LEFT: *Photograph of subject.*

MIDDLE LEFT: *Stage one.*

LOWER LEFT: *Stage two.*

RIGHT: *Stage three finished. Dimensions 8⁷/₁₀ × 11²/₅in (22 × 29cm).*

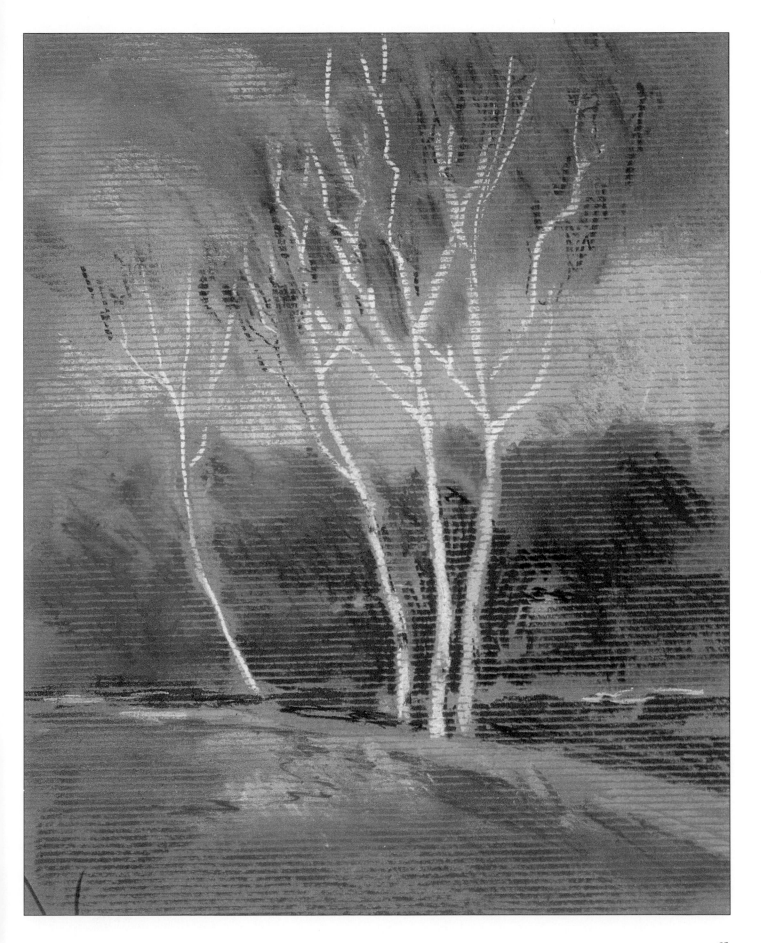

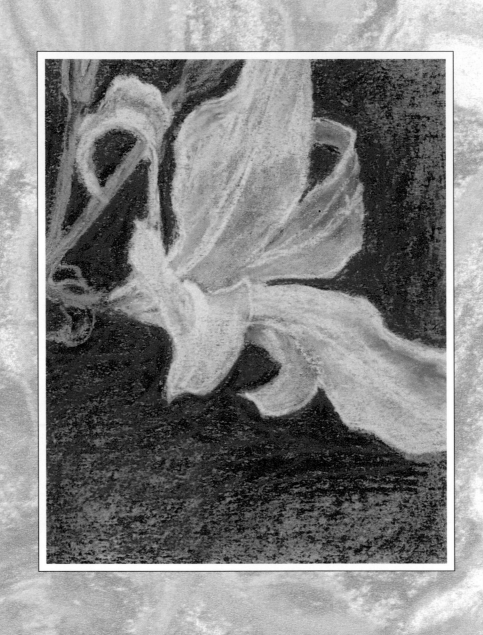

FIVE
FLOWERS

Flower painting is at least as old as the Ancient Egyptians, who in their tomb paintings used the slightly stylized blue waterlily that flourishes in the Nile to symbolize a rich harvest. The Romans were less interested in symbolism than in reality, and at Stabiae, in the shadow of Vesuvius, a wealthy citizen commissioned an artist of great talent to fresco his seaside villa with images of maidens tripping through a spring meadow gathering flowers. So delicate is the artist's touch, and so bright his tones, that it might be a pastel.

Another 1400 years were to pass before another major artist, Sandro Botticelli (c 1445–1510), would use nature as an integral part of his paintings. By then the flower subject had come full circle, through the minutely observed plants of the *Codex Vindobonensis* – drawn in Constantinople in the sixth century AD from Classical Greek sketches – to the equally detailed decorations in medieval Bibles and breviaries. The monks, who originally grew plants and flowers for their medicinal properties, also learnt to contemplate their earthly beauty as an aid in appreciating the eternal. The monastery garden, the model for the medieval concept of the *hortus conclusus* (the secret, fruitful place at the centre of the City of God) provided the imagery for the rites of the Virgin and the Passion, often associated with bowers and garlands of roses, with the life-force symbolized by the vine.

Some of the greatest abbeys were in the south of Italy, near Salerno, where the famous medical school benefited from links with the Arabs, who introduced the botanical and medical secrets of the Ancient Greeks to Western Europe via beautifully illustrated texts. The laity also took up the gardening habit – by the middle of the Hundred Years War we hear of Charles VI of France planting the garden at l'Hotel St Pol with red and white roses, lilies and irises. The medieval princes used floral motifs for the tapestries in their great halls. Among the plunder the Swiss took away from the Burgundian camp at Grandson in 1476 was a large *millefleurs* tapestry, in which with the ducal arms, with the royal French lilies prominent, is woven into a field of accurately observed flowers. This is now in the Berne Historical Museum. Similarly, the famous tapestries known as 'The Lady and the Unicorn' in the Cluny Museum, Paris, are liberally woven with naturalistic flowers.

The depiction of flowers was one element in the Humanistic tradition which was passed on by the Burgundians to the Dutch. The same power of observation found in Van Eyck's Ghent altarpiece is also seen in the later flower studies of painters such as Jan van Heem (1606–1684) and Jan van Huysum (1682–1749). This was the period of the Dutch 'tulip mania', when growers competed for ever more exotic species, and portraits of flowers began to compete with those of the lace-collared burghers and their families as family 'official' subjects.

Many of the blooms in these rich floral displays, sometimes posed against Turkey carpets, had been raised from bulbs and cuttings brought back in the ships of the East India Company from Holland's new possessions. The botanical artists who accompanied those first expeditions recorded the rare species they encountered with the same care with which the monks had painted the European wayside flowers. And their successors, in the expeditions of Cook and Bougainville in the eighteenth century, helped to create a demand for exotic flowers and plants which continued into the nineteenth. Flowers then became the subject matter of the Impressionists, and the fashion has never died.

HOW TO BEGIN

Of all painting subjects, flowers are at once the most delightful and the most difficult. Their complex and delicate structures have to be fully understood so that when you draw them it seems to be done with a minimum of effort. The Chinese will copy a bloom again and again, until they can capture its essence in a few brushstrokes.

I believe that the best way to approach the subject is first to examine the individual blossoms carefully. The flower is such a fleeting thing; changing from bud to flower and then beginning to fade and die as you work. Before you begin your study it is best to leave them up to their necks in a vase of water for a few hours. This is what the florists call 'conditioning', and it will give the flowers a longer life span. Begin with individual blooms, using pastel pencils or hard pastels on tinted paper. The rule is to follow the line of growth of the plant, starting with the stem and continuing up so that you are following the natural movement.

RIGHT: ODILON REDON, 1840–1916, *Meadow Flowers in a Long-necked Vase*, Louvre, Paris
Redon frequently used the techniques that he had perfected in working with charcoal, putting in fields of colour to set off his exquisite flower studies. Here he has used soft pastel on paper. He would either blend them thoroughly or use them crushed to produce the very soft-edged areas which give the composition weight and unity.

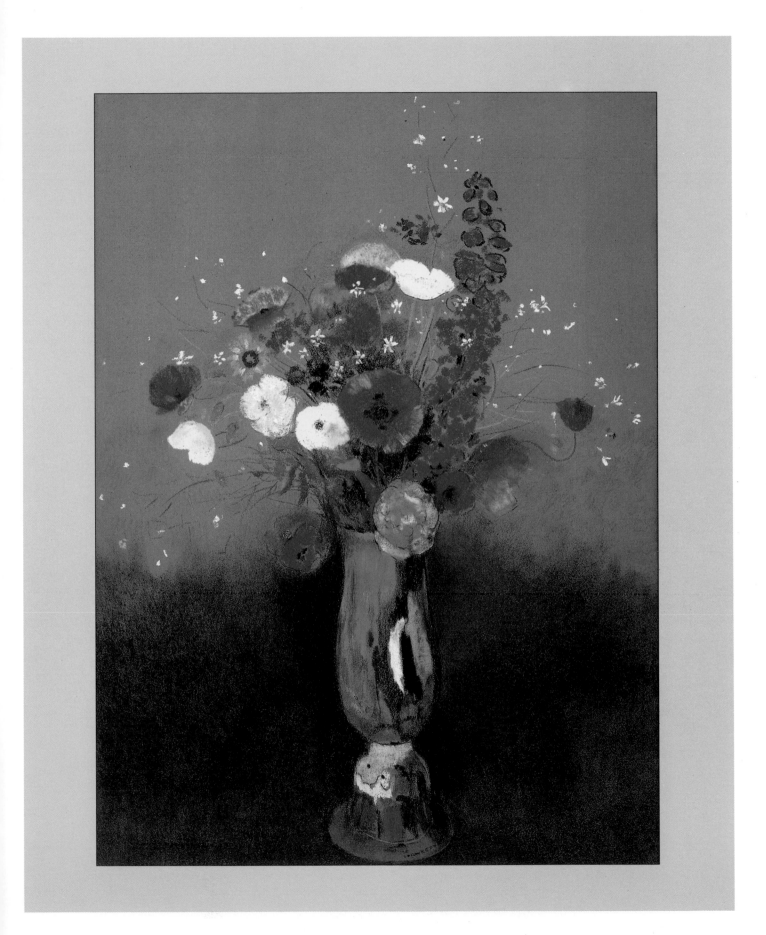

ALSTROEMERIA

Stage 1: I was very interested in the movement of this delicate flower so I chose pastel pencil and white paper in order to give the drawing a light and fragile feeling. I have begun by drawing in the flower simply with pastel pencils, moving upwards from the stems as described in the section above.

Stage 2: I have now changed to hard pastel to draw in the blossom, using alizarin crimson. At the outer edges of the petals the line thickens and, using a blending stick and my finger, I have shaded in the pigment from the outer edge of the petals down into the throat of the flower.

There was no need to add white since the white paper underneath showed through to give a gradual shaded effect. I have used a pastel pencil for the leaves, stamens and details of the petals.

Stage 3: With the flowers completed, I have added a background colour with soft pastel, indicating shadows from the leaves with pale blue soft pastel.

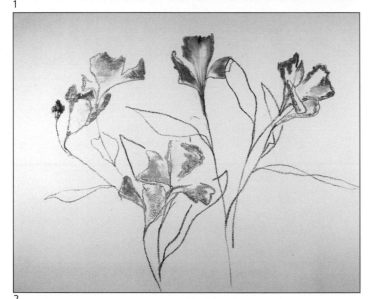

1

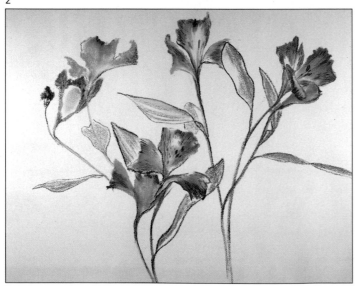

2

3

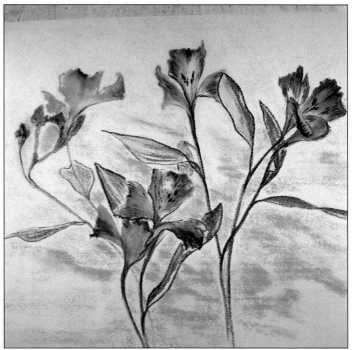

4

RED AND
WHITE TULIP

Stage 1: Here I have used a technique called silhouetting, which is useful when you wish to make a detailed and delicate sketch with very sharp definition. First I made a drawing, which I traced and then cut out.

Stage 2: I fixed the tracing to the drawing, with bits of rolled-up masking tape placed underneath to avoid damaging the paper.

Stage 3: I then rubbed the tracing and the paper with soft French ultramarine pastel, smoothing it with my finger before lightly spraying it with fixative.

Stage 4: The tracing was removed, leaving a perfectly clean silhouette of the flower. Since the background has been fixed there is little problem with smearing or picking up the blue background when I fill in the details of the flower itself. The next illustration also involves a form of silhouetting but gives a very painterly effect.

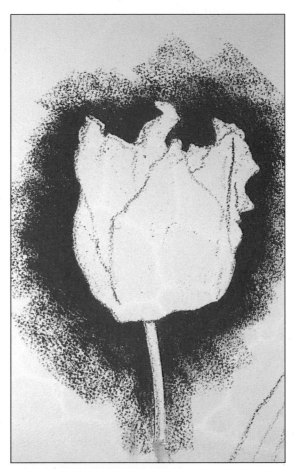

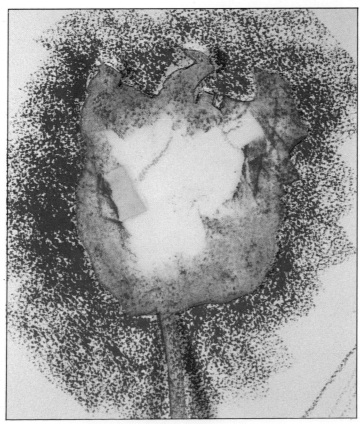

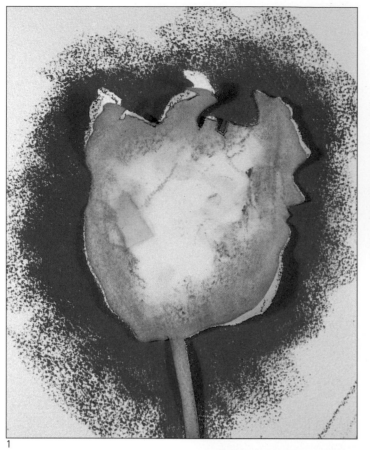

1

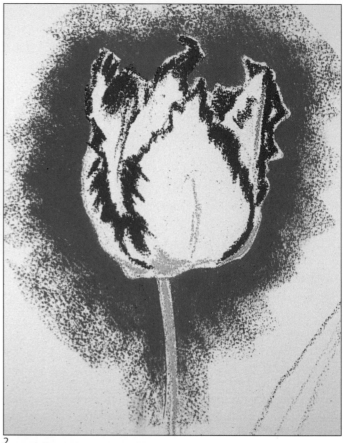

2

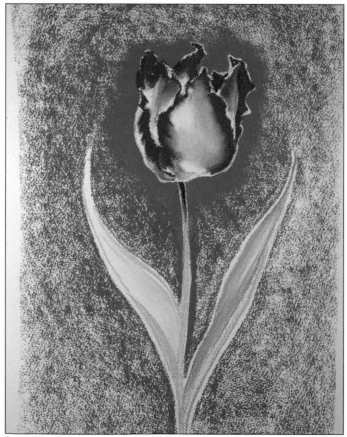

3

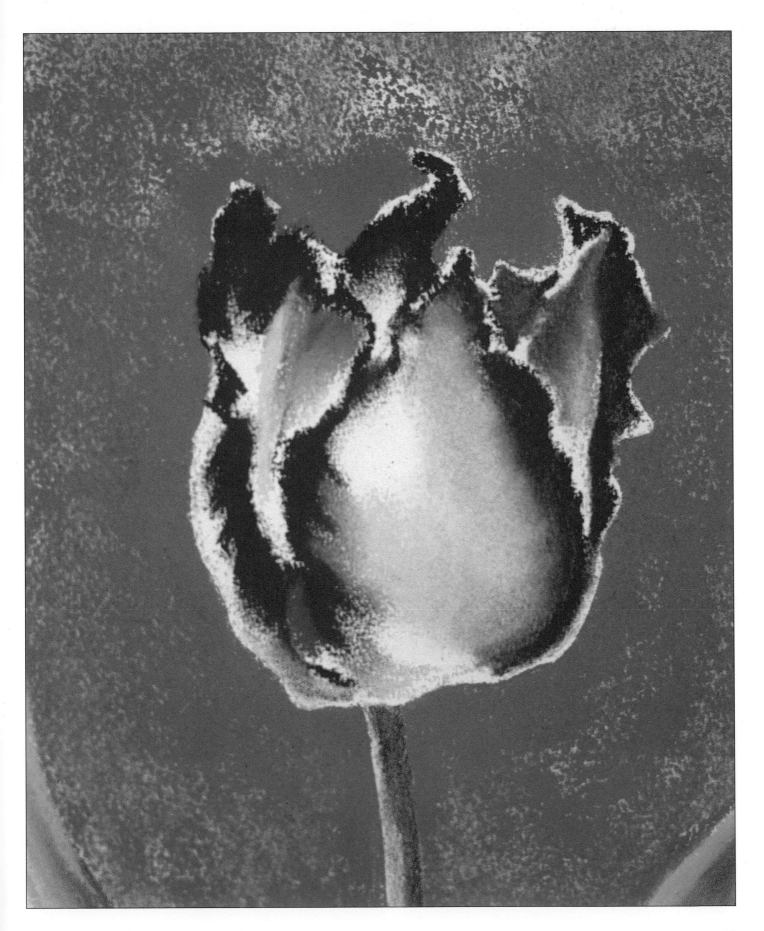

BLUE IRISES

This was done on watercolour paper which had been prepared by rubbing it lightly with a block of scene-painter's charcoal. This not only gives an interesting ground colour but also mixes well with the pastel colours to provide a slightly silvery effect, or a warm grey. The stems have been drawn with hard pastel and the flowers with soft, and they have all been worked on together to build a pattern of shapes. Soft pastel has been added to the background and blended with the charcoal, using soft tissue.

1

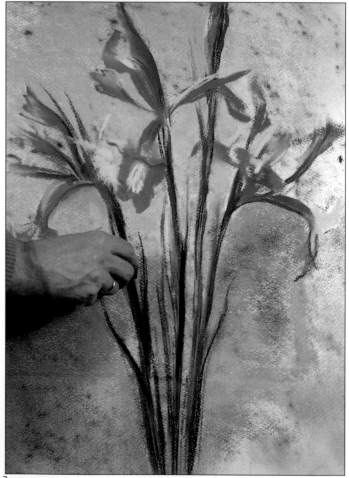

2

TOP: *Preparing the paper.*

RIGHT: *The finished piece.*

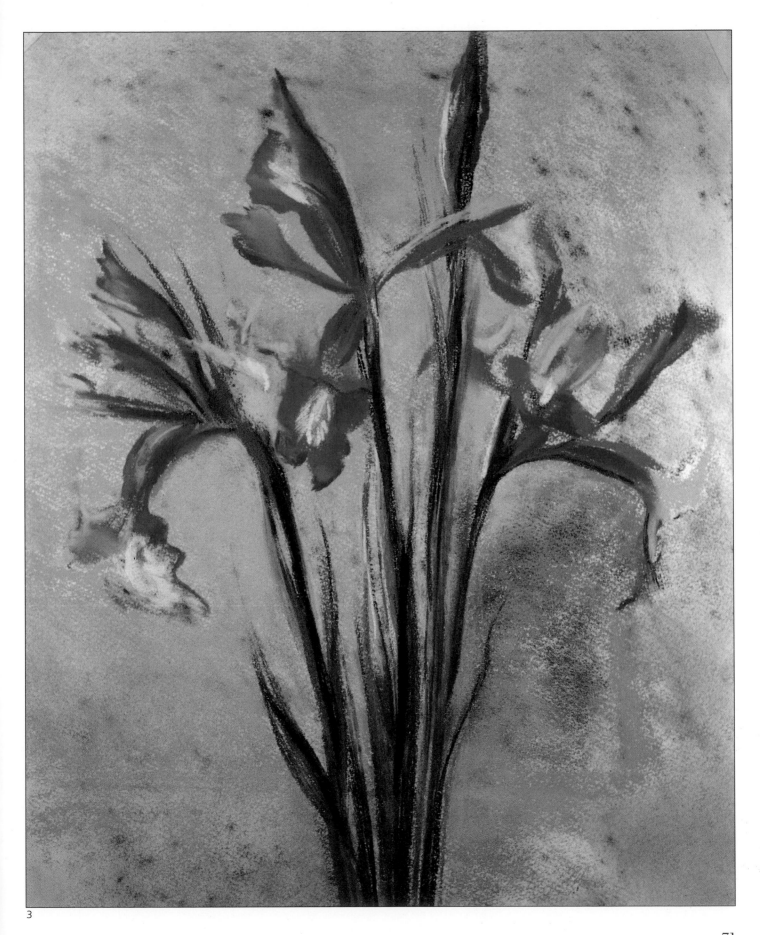

3

YELLOW LILIES

These demonstrate a very unusual and interesting technique developed by one of my students. The flowers were drawn in carefully with a finely sharpened pastel pencil, after which the backgrounds were carefully filled in, using soft pastel and hard pastel, both sharpened. Two colours were used to give variety and liveliness. The drawings were then very heavily fixed to prevent picking up the background colour and spoiling the clean tones, and the petals were filled in with a light yellow ochre, which was in turn fixed to allow the highlights to be picked out in bright lemon yellow with a soft pastel. The details of the stems were done with a pale viridian.

The same method was used for both flowers, with slight variations of colour. The key to working in this manner is careful drawing to begin with so that nothing has to be changed, and using plenty of spray fixative between the stages to keep the crispness. The artist worked from hard to soft, beginning with pencils, moving to hard pastels and then the softest pastels for the highlights.

'Yellow lilies' by Bruce Argue. Dimensions 7½in (19cm) square.

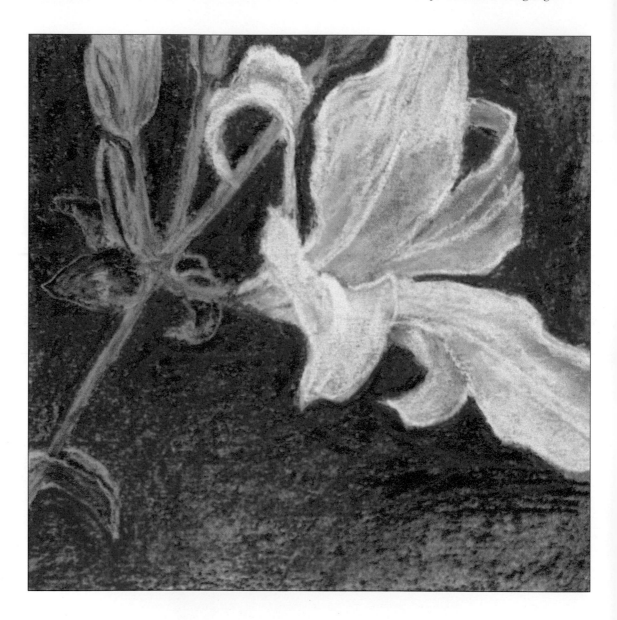

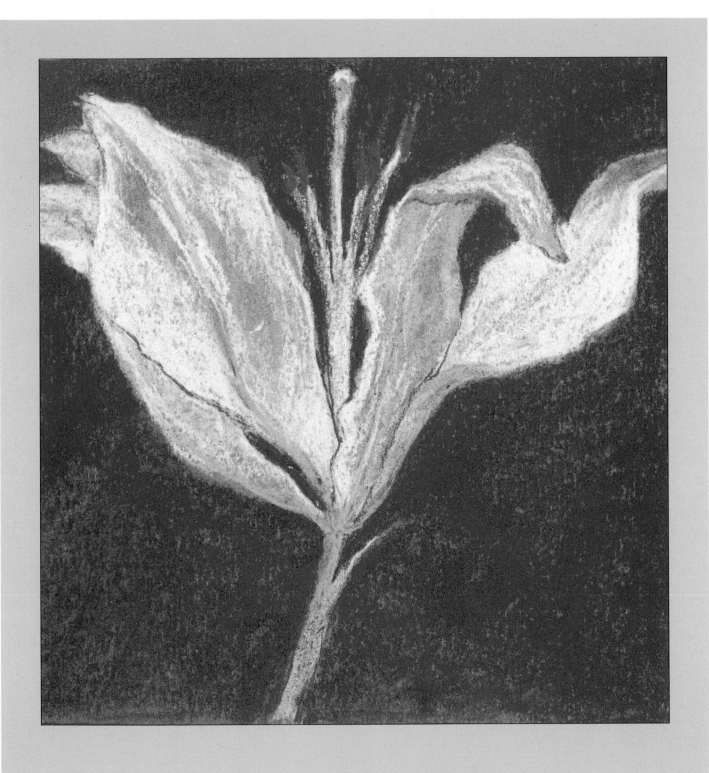

LILACS

A bouquet of flowers is quite different from individual blooms, so I have used a simple plan to demonstrate the process of building up the composition. It is best to consider the study as a collection of shapes of varying tones, and not think at the outset of the details of the individual flowers.

Stage 1: I have drawn in the basic shapes of the flowers with a light blue soft pastel, working on tinted pastel paper.

Stage 2: I have used alizarin crimson for the table and a dark yellow ochre for the background. I need these colours at the outset to frame the flowers so that I am working against a background, though I will deepen and change them as I proceed. Obviously when one is painting a light-coloured object the background is of vital importance.

Stage 3: I have laid in the varying colours of the lilac with the side of the pastel, applying very little pressure so that I achieve a broken effect which resembles the soft dappling on the blooms. I have used the point of a dark brown pastel to pick out the shadows in between the blooms to define their shapes.

Stage 4: Before putting in the green of the leaves I have lightly sprayed with fixative so that it will not mix with the colour underneath. Slightly different colours have been used to highlight the flowers, and the colours on those at the back have been blended to give contrast of texture and a feeling of depth. The blues of the vase and its reflection were added after the area had been given a very strong spray of fixative, indeed the colour was laid on while the paper was till damp from the fixative, to make it take.

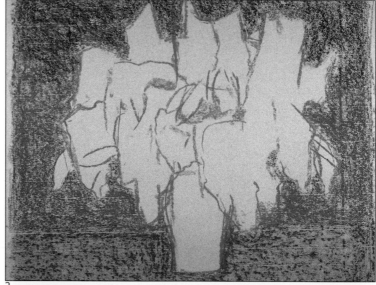

1

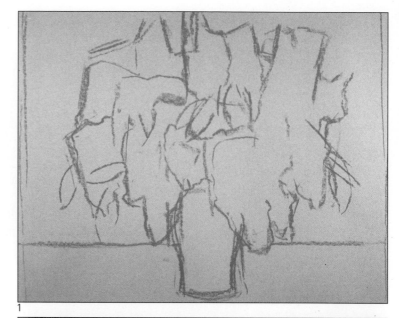

2

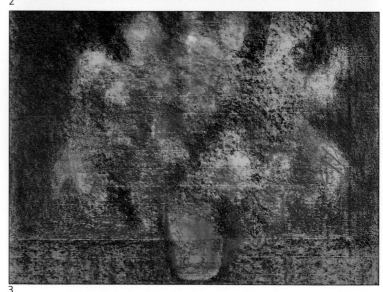

3

74

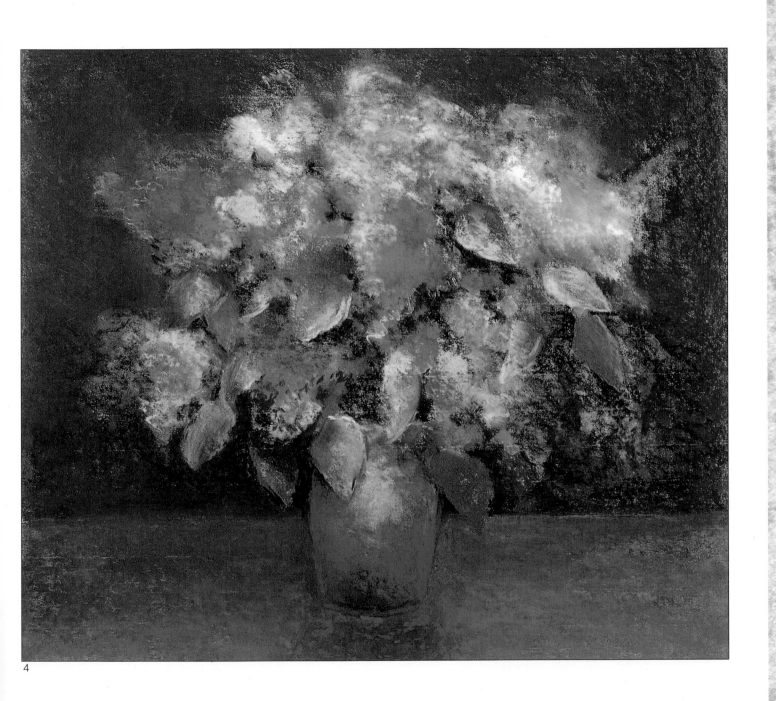

4

STATICE

This is a simple drawing, done with hard pastel on paper prepared with a wash of yellow and green watercolour (see page 23). The first step was to draw the stems. Then I placed the flowers, using two shades of mauve to give depth, after which I used a light cadmium soft pastel in the background behind them. Since yellow is the complement of mauve it brightens the flowers and brings them forward – complementary colours are always used to reinforce each other. The other two pairs of complementaries are red and green, and blue and orange.

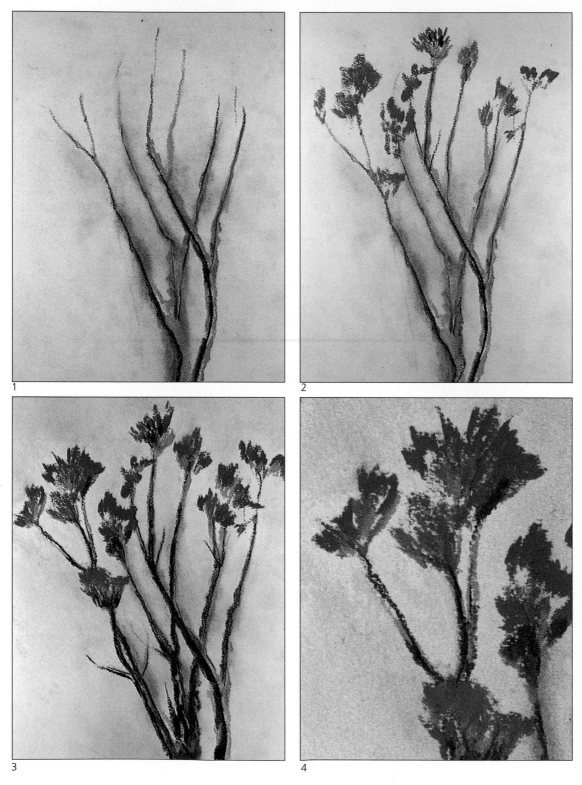

1

2

3

4

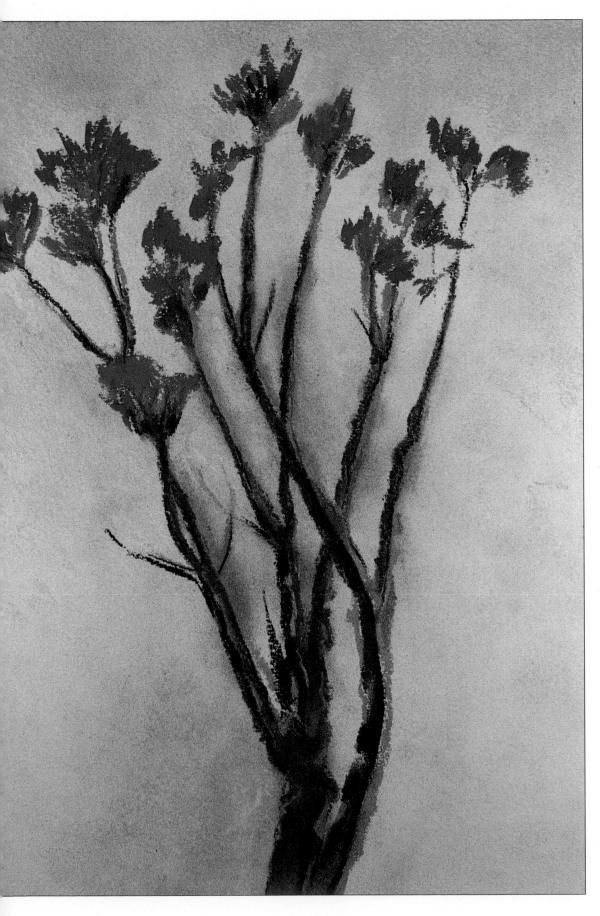

Dimensions
12 × 9⅘in (30 ×
25cm).

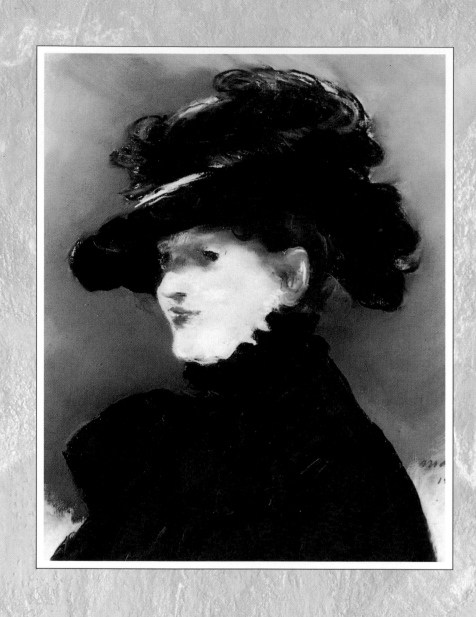

SIX

LIFE & FIGURE WORK

PORTRAITS

In ancient societies, the portrait was seen as the means of capturing and preserving the spirit of a person. The name the Egyptians gave the sculptors who made the immense heads of the Pharaohs was 'he who keeps alive'. These were carved in granite the hardest stone known, while the bodies were embalmed and preserved.

The Greek search for perfect symmetry and balance in art and architecture led to an idealization of the human form, but the idiosyncrasies of the human face began to emerge in the golden age of Periclean Athens. We have a fine portrait bust of Socrates, while the Macedonian royal house used their own images on coins to proclaim their expanding empire.

For 'warts and all' portraiture the world had to wait for the Romans, supreme realists, who in depicting their semi-divine emperors applied the lesson recited at all their triumphs – 'Remember thou art only a man.' Vespasian, who had statues and triumphal arches erected to his military prowess throughout the empire, comes down the

RIGHT: FRANÇOIS
LEMOINE, 1688–1787,
*Head of the Goddess
Hebe,* 12¼ × 10⅛in
(31.1 × 25.9cm),
British Museum,
London
*Lemoine specialized in
decorating ceilings on a
monumental scale, and
this pastel on blue paper
was done as a cartoon
for the Salon d'Hercule
at Versailles. We can see
from the foreshortening
of the head that it was
meant to be viewed from
below. The fine blending
of the flesh tones contrast
with the lively linear
drawing of the flowers in
the goddess' hair. The
pastel is in immaculate
condition and looks as
bright as the day it was
finished, which attests to
the durability of the
medium when kept
properly.*

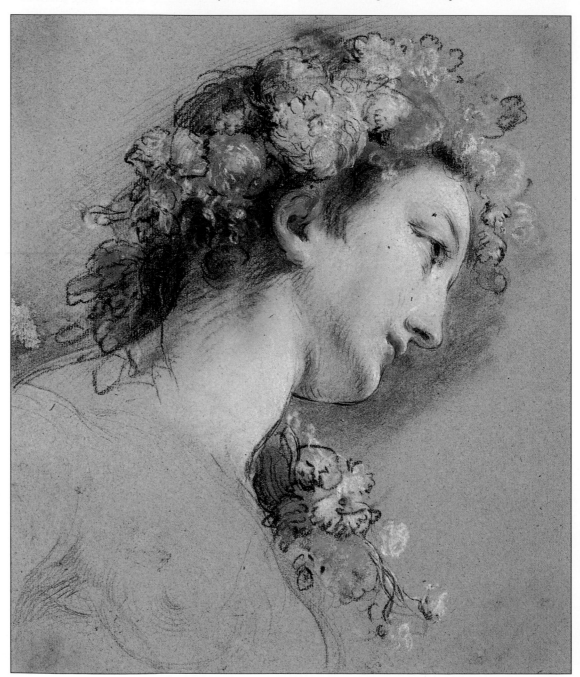

LEFT: MAURICE QUENTIN DE LATOUR, 1704–88, *Study for a Head of Voltaire*, National Museum, Stockholm *This drawing in soft pastel on paper is the sole survivor of two sketches and a finished painting which de Latour made of Voltaire at the beginning of his exile at the Chateau of Cirey in the duchy of Lorraine. He had withdrawn there after the Paris hangman had publicly burnt his* Lettres Philosophiques sur les Anglais, *which unfavourably compared French institutions with English. In a letter dated 12 April, 1736, addressed to the Abbé Moussinot, Voltaire asked for his portrait to be sent to him after two copies had been made. The medium has caught the wit and intelligence of the man for all time.*

ages as a tough pragmatist with an intelligent, quizzical gaze. A few years ago, archaeologists digging up Roman cities in Egypt found themselves face to face with his subjects, as Roman settlers and their families had their likenesses faithfully recorded on the lids of their coffins.

In the Middle Ages, kings sat for their portraits, for example the young Richard II can be seen in the lovely Wilton diptych in the National Gallery, London. But the official portrait only came into its own with the oil medium, an innovation credited to Jan Van Eyck in the fifteenth century, and used by Jean Fouquet for his coldly truthful painting of Charles VII, betrayer of Joan of Arc. Wealthy north European patrons, and particularly the Dutch, continued to commission their likenesses in oils, which were less susceptible than pastels to the damp atmosphere. Also their lustrous, dark tones suited the northern house interior.

The dry climate and light and colour of the south, however, were well suited to pastel, and the Venetians in particular took to it with enthusiasm. Because pastels could be done in half the time or less, the cost was lower, and portraits, which had hitherto been restricted to the aristocracy, were now within the reach of the middle classes. Thanks to this, we now have an admirable record of the people of the time.

Portrait painting is as popular as ever today, in spite of photography, and artists continue to pursue a quest similar to that of the ancients – that of attempting to capture the spirit of a person. For portraiture is more than just achieving a likeness, a really good portrait should express something about the sitter's character and tastes.

BELOW: *Detail. Couple on soft charcoal background; dimensions 9⁷/₁₀ × 12in (50 × 60cm).*

DRAWING AND PAINTING WITH PASTELS

LEFT: EDOUARD MANET,
1832–83, *Mery Laurent
with a Large Hat*, 21¼
× 17¼in (54 ×
43.8cm), Musée des
Beaux Arts, Dijon
*Unlike Delacroix, who
was content to use pastel
only as a sketching
medium, Manet
exploited its velvety
qualities to the full in
complete portraits. Here
he has used cardboard,
which he favoured as a
working surface,
frequently allowing the
colour to show through.
The painterly quality is
the result of his practice
of using a stump or his
hand to rub in large
quantities of pastel.
Although it appears that
he has used black in this
study, he was in fact a
master of very dark tones
of rich colour – the hat is
actually the deepest
possible brown and the
dress a lustrous indigo.
The work is a fine
example of a strong
tonal composition, with
the white face framed
dramatically to
emphasize its delicacy.*

RIGHT: *Stage one.*

BOTTOM LEFT: *Stage two.*

BOTTOM RIGHT: *Stage three. Dimensions 9 × 12in (23 × 30cm).*

RIGHT: *'Portrait of an Old Woman' – pastel on cardboard.*

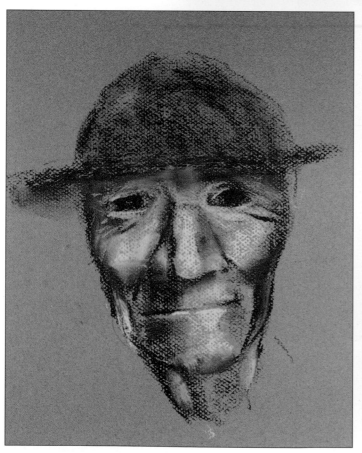

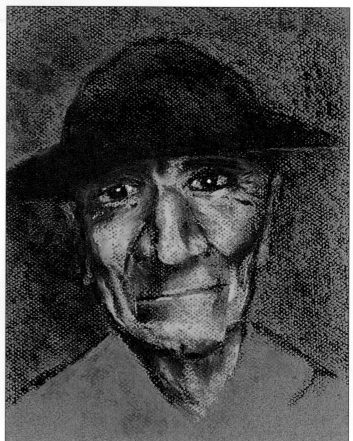

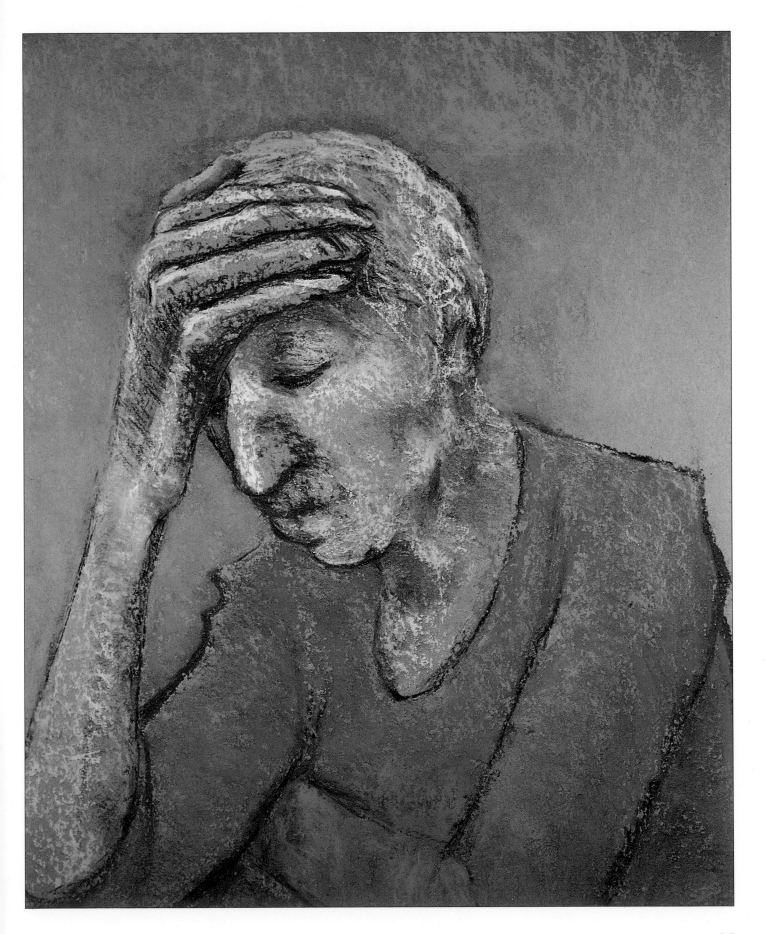

STARTING WORK

Your first task, and a very important one, is to put the sitter at their ease and make them comfortable, thus avoiding tiredness, irritability and self consciousness. I generally let my sitters choose their own poses as they will be the easiest to hold, and I make sure that the room is warm enough, as holding a pose for a long time can cause the model to cramp up. Decide whether you want the sitter to be gazing out at the viewer in the finished picture; if so they must look directly at you. If you want a more introspective pose, position the head in the way that you want it and then ask your sitter what he or she is looking at. Keeping the eyes on one particular object in the room will help the model to concentrate and prevent the head and eyes from moving.

You will not be able to produce a really successful portrait unless you can get beneath the outward appearances and understand the shape and porportions of the skull. Both Michelangelo (1475–1564) and Leonardo da Vinci risked imprisonment to gain the valuable anatomical knowledge that allowed them to produce such convincing representations of the human face and figure, stealing into the mortuaries of Florence to carry out dissections and make drawings throughout the night. Fortunately such drastic steps are no longer necessary.

So let us take a close look at the skull. It has been described roughly as having the shape of an egg with the axis at an angle, running from the chin through the back of the skull. But as we look at it in more detail we find that the length of the skull from the bottom of the chin to the crown of

BELOW: *Anatomical drawing of the skull done with pastel pencil, heightened with soft pastel. Dimensions 27½ × 21³/₁₀in (70 × 55cm).*

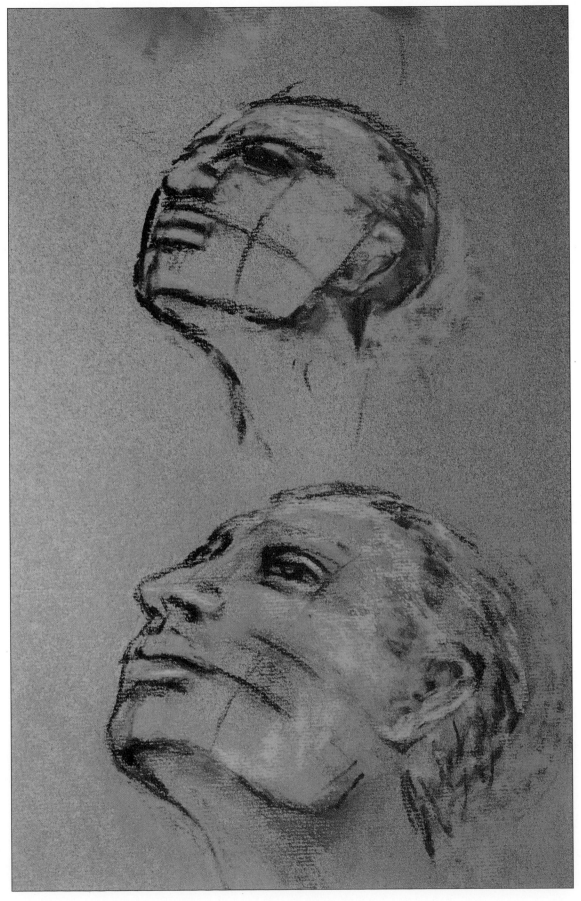

LEFT: *Placing the features with the head turned. Dimensions 19⁷/₁₀ × 24in (50 × 60cm).*

the head is approximately equal to the depth from the front of the face to the back of the cranium. The cranium is larger than we generally suppose, so a careful measurement is necessary.

In the placement of the ears the top of the ear aligns with the top of the eye socket and the bottom of the nose. The ear fits in directly behind the jawbone, which is slung below the cheekbones, creating a hollow. This is aligned with the bottom of the nose.

This knowledge of the skull's structure helps us to map out the shadows and highlights which give the form to the face. Since people do not normally carry their heads perfectly upright it is as well to know how to place the features correctly when the head is at an angle, or foreshortened when looking up or down. The lines of all the features are seen as parallel curves. When the head is thrown back, for example, the features closest to you will be larger, with the others diminishing slightly, but the rules of the parallel curves still hold.

So, once we have grasped the shape of the head and the basic placement of the features, how do we set about achieving a likeness? One of the elements that makes each face distinctive is the fact that the features are not symmetrically placed. The head of a baby in the womb closes from back to front, so the line that runs through the crown of the head through the nose to the chin is seldom perfectly straight; it curves slightly to the right or the left in most people. This is why film actresses and other public figures like to make sure that photographers shoot them from their 'good' side.

Another is to measure the distance between the eyes and then down to the point of the chin, forming a triangle. This is the best way to map a person's face and position the features, which vary enormously between individuals. To make this measurement, stretch out your arm, holding a pencil horizontally, and looking at the model from where you stand. Position the pencil so that one end aligns with one eye, and then mark with your thumb where the other eye is. Continuing to hold this measurement, turn the pencil, and see how the distance between the eyes compares with that from the eyes to the point of the chin.

This is the traditional way the artist measures up the subject. Sculptors use calipers because they are working in three dimensions and take the measurements directly from the head. Making a

small schematic sketch of the head before you begin the finished portrait can be very useful in sorting this out. If the features are placed accurately and the shape of the skull is right, half of the work is done and you are well on your way to a good likeness.

PORTRAIT OF DAVE

This shows how the drawing has been laid in on tinted pastel paper. I have used a dark grey pastel for the line, with light ivory and flesh colour for the highlights. This is the way that I build up all of my portraits.

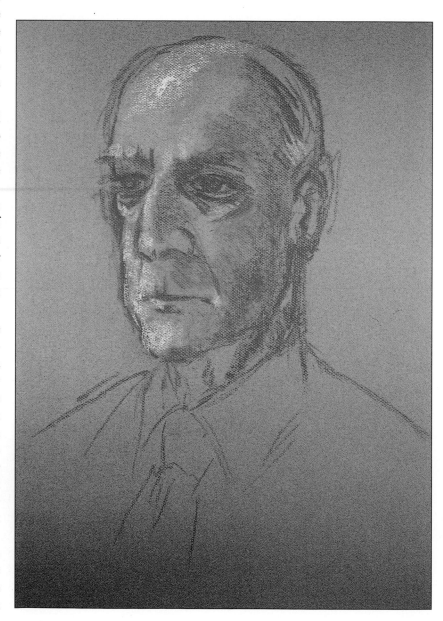

BELOW: *Preliminary sketch for portrait of Dave Bowman; dimensions 27½ × 19⁷/₁₀in (70 × 50cm).*

PORTRAIT OF
JOHN PIPER

I worked in soft pastel on watercolour paper, over which I rubbed a block of scene-painter's charcoal. The dramatic effect was achieved by using soft black pastel on the right side of the head, which is in deep shadow, and picking out the highlights on the left side with the palest viridian green line. I used a minimum of colour, just smoothing out the background with a light pink soft pastel.

BELOW: *'Portrait of John Piper'; dimensions $27\frac{1}{2} \times 19\frac{7}{10}$in (70 × 50cm).*

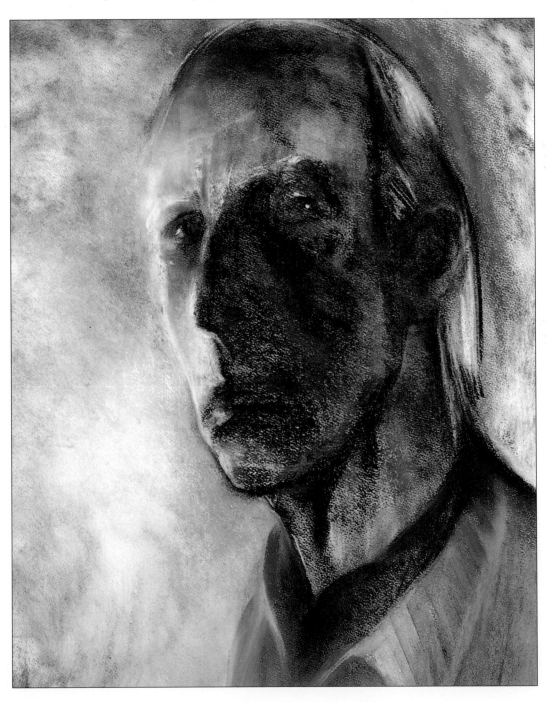

RIGHT: *Stage one.*

FAR RIGHT: *Stage two.*

OPPOSITE PAGE:
*Completed portrait.
Dimensions 24 ×
17⁷/₁₀in (60 × 45cm).*

PORTRAIT OF
NOOSHIN

Stage 1: Working on tinted pastel paper with soft pastel, I have drawn in the head and the features with a grey pastel. I never use pencil as the line is almost impossible to erase, whereas an underlying pastel drawing is easy to incorporate into the other tones.

Stage 2: After blocking in the features I have put in the shadow areas and the background at the same time, and then the flesh tones of the face. I have continued working on the face with a light ochre soft Schmick pastel, which gives an ivory tint and brings out the highlights. The face is side-lit, which gives a greater feeling of depth and form. I have used a harder pastel to draw in the details of the features.

Stage 3: I have asked the sitter to look directly at me so that I could draw her eyes looking out at the viewer. I have indicated her jumper only very lightly, but considerably increased the colour in the background. With a portrait, like any other subject, you should work on all the elements together, because they interract with one another, and background colours frame and shape the head. I have used some of the blue of the background colour on the shadow area on the right side of the face. The sitter has a very strong bone structure, and you can see her cheekbone and the structure of the skull, with the deepset eyes, very clearly. The dark hair forms a dramatic frame for the face.

This portrait is basically a drawing in pastel rather than a painting, with the soft pastels being laid in very lightly for both shadows and the highlights.

90

LIFE AND FIGURE WORK

PORTRAIT OF AN OLD MAN

For this very simple pastel painting I have used a greyish-blue tinted pastel paper. As I have mentioned before, this has a shallow texture, and when you use it with very soft pastels the surface tends to fill up quickly.

Normally this is a disadvantage, as the pastel begins to blend and smear too much, but in this case I have decided to make use of the effect to give me a very soft skin texture.

Stage 1: I have laid in the background with a dark chrome green, passing over the surface very lightly. This colour has also been used in the shadow area of the face, with the lighter tones put in with an ivory soft pastel.

Stage 2: I have now drawn in the features with red oxide, which is a burgundy colour, and have used a small amount of black to accentuate the eyes. I have used the smearing tendency of this soft pastel by rubbing the background.

I have found that rubbing with the side of my hand, which is a dry, broad, flat surface, is better than fingertips or a blending brush. The brush tends to knock the pastel off the surface, whereas if you use your hand you push the pastel into the surface and do not lose as much of it.

Stage 3: The green and ivory pigments blend together very subtly. Since I have picked up the colour on the side of my hand the nuances of shading can be stated very easily by just a light touch.

I have redefined some of the details and highlights as I worked by laying in more of the lighter ivory colour where it is needed.

With this soft modelling technique, you continue the process until you reach the desired effect, but you need to proceed slowly, watching the change of the tones carefully. The danger is that in the blending you will smear the work too much and lose the definition.

If you find this happening, spray with fixative, and then increase the definition by putting in more light and dark. When you have finished give the work another very light spray of fixative.

1

2

94

PORTRAITS OF A
YOUNG WOMAN

These have been done on flour paper, the softest grade of sandpaper. I have used soft pastel, with hard for the details. Working on this paper allows you to achieve a very painterly effect quickly, as the pastel rubs off and sinks into the paper in great quantities. The colours can be overlaid, as in the hair here where I have applied a darker brown over the light orange, but it is very difficult to blend or move the colours around on the surface.

Portraits of a young girl done on flour paper; dimensions 9 × 7½in (23 × 19cm).

PORTRAIT OF AN OLD WOMAN

This is an example of pure pastel drawing. I used the darkest shade of grey, which has indigo in it. This gives me a very rich, dark but sensitive line which can vary in texture and intensity, more than charcoal. Dimensions 27½ × 21³⁄₁₀ in (70 × 55 cm).

PORTRAIT OF A MAN WITH RED BEARD

Working in soft pastel on watercolour paper, I drew in the head with a light colour and then put in the background to frame it. Since the sitter had a very pale skin I wanted to use a minimum of colour in the face itself. The features were drawn in with pastel, and light green was added to the areas in shadow. Then a light ivory soft pastel was blended in throughout, leaving just a small shadow of the green showing through.

LIFE AND FIGURE WORK

PUTTING THE FIGURE IN CONTEXT

Until the nineteenth century figure composition was only considered as a fit subject when it was in the context of historical, allegorical or religious painting. There were exceptions, of course, mainly in the Low Countries, where artists such as Jan Vermeer (1632–75) painted contemporary subjects in a clear Renaissance light. The clear, bright colours of those other masters of light, the Impressionists, has tended to blind us to another facet of the revolution they began – the belief in the validity of everyday life – people walking in the park or a humble corner of the countryside – as the subject matter of paintings.

Two of the Impressionists' important precursors were Gustave Courbet (1819–77) and Jean François Millet (1814–75). The latter's reverential yet realistic portrayals of peasants at work and rest, many done in oils, but some in a mass of small strokes of pastel, had a profound influence on Van Gogh, who used a related medium, charcoal in his early depictions of the wretched conditions of the peasants in his native land.

But the real revolution in the depiction of the figure in contemporary contexts was brought about by Degas and Henri de Toulouse-Lautrec (1864–1901), who portrayed hitherto taboo subjects, like the world of the brothel and the cabaret, presenting the bitter smile of the whore, the exhaustion of the washerwoman and seamstress and the dull stare of the absinthe addict with a complete lack of sentiment. When fashionable Paris threw up its hands in horror at Lautrec's study of a woman undressing while watched by a man, the painter simply said, 'evil is in the eye of the beholder'.

Building a composition

It may be helpful to go 'behind the scenes' and take a look at the way some narrative or figure compositions are put together today. Artists have built on the experimental base of Degas' work, and are constantly using new technology in a way that would surprise – and perhaps shock – many people. There is no reason why you should not

RIGHT: 'Woman with Yellow Hair.' Paper was rubbed with charcoal before pastel drawing. Dimensions 21¹⁄₅ × 28⁷⁄₁₀in (54 × 73cm).

OPPOSITE PAGE: 'The Penny Arcade, Soho'. Dimensions 37²⁄₅ × 25³⁄₅in (95 × 65cm).

use some of their methods in your own work if you wish. One of these is to make use of photographs, either combing newspapers and magazines for exciting images or using your own holiday pictures or family snaps. Either the whole image or parts of it can form the basis for new compositions, and these elements can be enlarged or reduced in size on a photocopier – these are now found in almost any high street. You can experiment in many ways with your photocopied work, cutting up images, enlarging some and reducing others, and moving them around until you find a composition that 'gels'. Many of the new photocopiers can also make colour copies and enlargements. The colour will be rather distorted on the enlargements, but this can actually be inspiring, as it gives a slightly surreal image.

Such methods are the standard practices of many artists today, but as a general rule mechanical methods should not be used exclusively. It is useful to make drawings of your own environment, even if you do not have a model at the time, and these drawings can be used on their own or combined later with figures into a composition.

The next problem is how to transfer a small sketch or collage of photocopied images onto a larger format. Professional artists and illustrators frequently do this by mechanical means, but for those without the expensive equipment required an excellent alternative is the time-honoured method of squaring up. This is an important skill and simple one to acquire. Select a support which is larger but has the same proportions as the work you intend to copy onto it. For example, you do not copy a square painting onto a rectangular support; the basic shape must be the same. Divide the work to be copied in half, from top to bottom and from side to side, and keep making these divisions until the work is covered with a grid of boxes approximately 2in. (5cm.) square. Then repeat the process on the support itself, but this time using a larger grid. If each square on your working sketch is 2in. (5cm.) and your chosen support is one and a half times the size, then your squares must be 3in. (7.5cm.) and so on.

For pastel work it is wise to use a light-coloured pastel pencil for the grid drawing so that it can easily be erased with bread. Finally, copy the image, square by square, from the sketch onto the support. If you don't wish to damage the original working drawing, cover it with tracing paper or acetate film and draw the grid on this.

WOMAN WITH THE FOX

Here I have combined photographs with visual memory. The central image was taken from a news cutting on Belfast, while the two men were recreated from memory. The woman reappears, greatly changed, in *Cityscape*.

The brick wall behind him is my garden wall. A fact of technical interest is that I drew the brick wall first, with the two girls, but then felt I wanted another element in the composition. To achieve this I sprayed the wall area with fixative and, using a very light touch with soft pastel, so that I didn't pick up the colour underneath, I drew the man's face directly on top, allowing some of the brick to show through.

LEFT: *'Woman with a Fox.'* Dimensions 29½ × 21⅗in (75 × 55cm).

WOMAN WITH CHILD

This is a painting of my sister, done entirely from memory. People remember much more than they think, and it really is possible, if you sit and concentrate on someone you know, to sketch their image. You may be surprised at how much it resembles them.

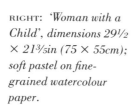

RIGHT: *'Woman with a Child', dimensions 29½ × 21⅗in (75 × 55cm); soft pastel on fine-grained watercolour paper.*

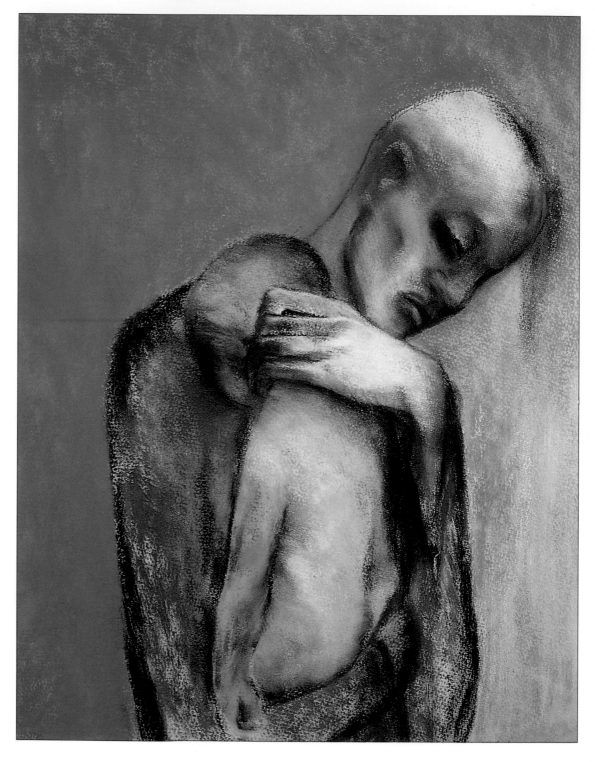

TIANANMEN SQUARE

My inspiration in this case came from a powerful
image in a Sunday newspaper magazine. I simpli-
fied the composition by picking out just one figure
of a student, which reconciled the symbols of vic-
tory and sacrifice. The background was rubbed
with scene-painter's charcoal, and soft pastel was
added to give a feeling of space and lightness
without it appearing too empty.

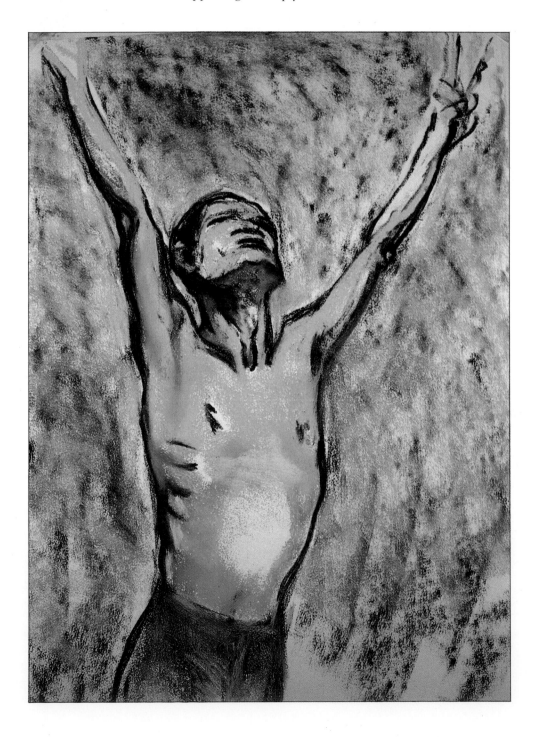

LEFT: *'Tiananmen
Square.' Quick sketch
with soft pastel; paper
rubbed with charcoal
beforehand. Dimensions
29½ × 21⅗in (75 ×
55cm).*

RIGHT: EUGÈNE
DELACROIX, 1798–
1863, *Slave Girl*, study
for *The Death of
Sardanapalus*, Louvre,
Paris
*Delacroix favoured
pastel for making
preliminary sketches for
his large paintings, and
there are many for this
important early work.
The finished picture,
which pre-figured the
exotic, oriental subjects
done after his visit to
North Africa, shocked
the art establishment.
The theme was taken
from Byron's drama
about a legendary
Assyrian king who
committed suicide with
his wives and slaves on a
gigantic pyre heaped
with his treasure. After
the painting was
exhibited, Delacroix
said that he became 'the
abomination of
painting; I was refused
water and salt'. 'But', he
added triumphantly, 'I
was delighted with
myself!' The pastel is on
buff-coloured paper, the
light flesh tones giving
the highlights and
direction of the body.
The work was overdrawn
with the details sketched
in pastel pencil or conté
crayon.*

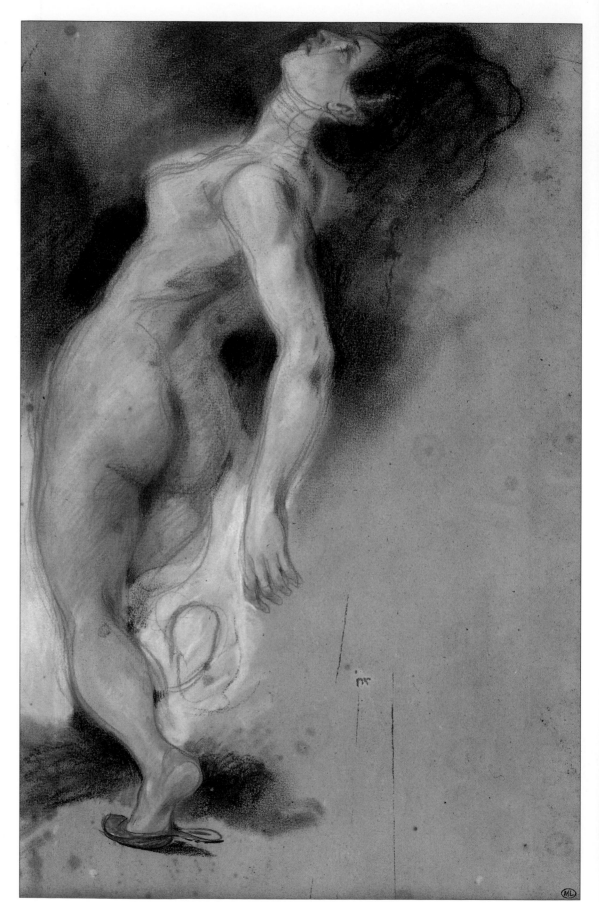

Drawing or painting the naked body, whether to extol the perfect form or to reveal it as it really is, has a long but chequered history. The Ancient Greeks, particularly in fifth-century Athens, aimed to show the body as the summation of man's highest aims – the manifestation of 'the gods come down in the shape of men'. This was an idea that was to outlive the fall of the Ancient world, and through the Renaissance, inspire all subsequent Western artistic development.

The Greeks, who exercised naked, deeply valued human beauty, and the standard set by the great sculptor Phideas in the Athens of Pericles was not matched until the time of Michelangelo, who like many artists of the Renaissance saw and wondered at the statues which were beginning to emerge from the earth of southern and central Italy. The statues of the Roman Empire tended to be portraits of Caesars, statesmen and soldiers, robed and armed, with nudity reserved for repre-

sentation of athletes, gladiators and slave girls. With the triumph of Christianity, the naked form was finally banned, and the writhing torsos of Odysseus and his men and the giant figure of the blinded Polyphemus, smashed almost beyond recognition and dumped by early Christians in what had been a pleasure grotto of Tiberius at Sperlonga, are mute testament to the wholesale spoliation of the legacy of the pagan world which went on in the fifth and sixth centuries AD.

The nude has, of course, always been a reflection of society's taste and changes in political opinion. The medieval artist was naturally bound by the Church's dictum that nudity belonged to the Devil. A ban included dissection of the human body. Piero della Francesca had to use as his model for Hercules a recently discovered Classical statue. Nudity was only considered permissible in representations of the crucifixion and martyrdom of the saints. Hieronymos Bosch (c 1450–1516)

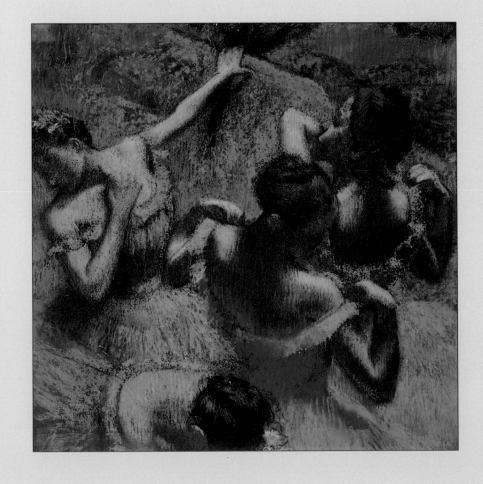

BELOW: EDGAR DEGAS, 1834–1917, *The Blue Dancers*, Hermitage, Leningrad
This, in soft pastel, is one of a series on heavy paper or card, probably done from the same model. At this period of his life Degas worked indefatigably, reworking the subject by tracing the poses from one study to the next. Frequently he would reverse the image by turning over the tracing or by counterproofing. His eyesight was failing and at this point, according to his friend Walter Sickert, who visited him in his studio, 'he could see only around the spot at which he was looking, and never the spot itself.' As he struggled against the blindness which was in the end to overtake him, he produced in his work a tremendous burst of light and energy, with the forms more simplified and the tones more brilliant.

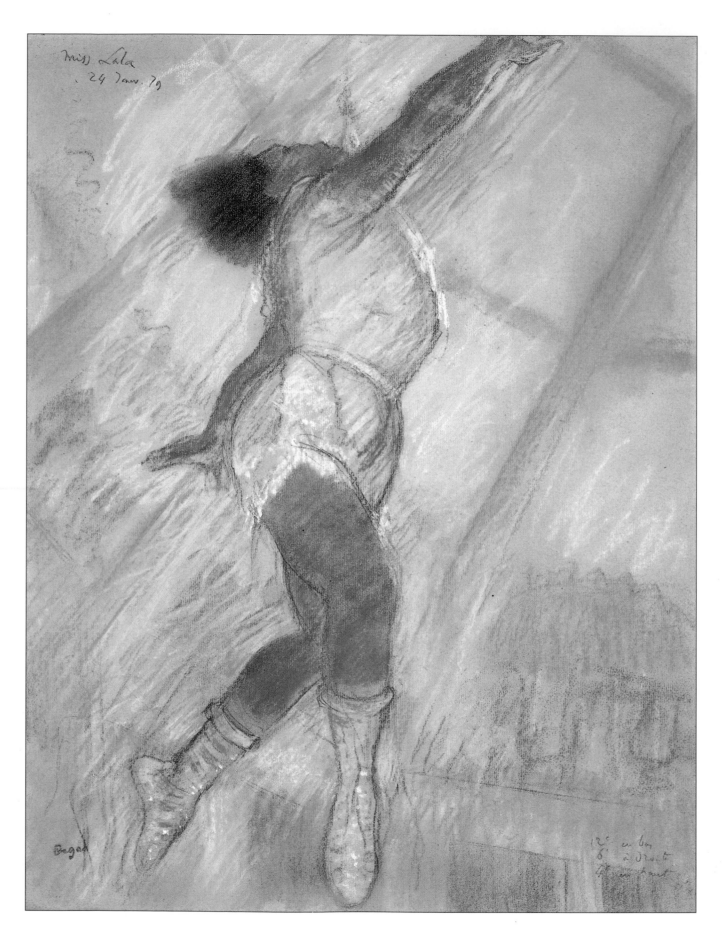

DRAWING AND PAINTING WITH PASTELS

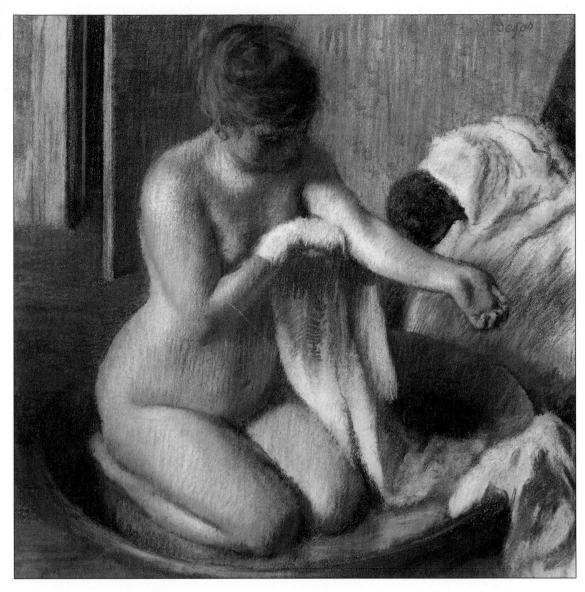

included many nubile nudes in his extraordinary pictorial fantasies, but they were all obviously temptations of Satan and suffering in Hell.

The new Humanism which came to fruition in the Renaissance could already be detected in Polliaulo's *Hercules and Antaeus Wrestling*, of 1460, and by the turn of the century Dürer's *Adam*, naked to the fates as well as to the viewer, sums up man's frailty and self-questioning. Which introduces the second way of looking at the nude. Michelangelo, Leonardo da Vinci and their contemporaries used notes made from dissections as well as observations of Classical statuary in their work. A century or more later, north of the Alps, Dutch and Flemish artists – some of whom had studied in Italy – sought their subjects from the Bible, but their models were the ordinary men and women of their own towns and villages.

Rembrandt sketched Cleopatra as a naked hausfrau, with a cobra coiled about her. His Bathsheba was a woman no longer young, running to fat and lost in her own thoughts, while his other model for a woman bathing was probably his own second wife, Hendrickje Stoffels. For about a century and a half afterwards the nude first became the province of the French aristocracy and then of the Revolution, which demanded unimpeachable Republican ideals in art. The nudes which were produced, however, often wearing only their caps of liberty or diaphanous chitons, were unconvincing as life studies.

It took the Romantics, and particularly Delacroix, to endow the nude with humanity and sensuality, placing his lush female figures in

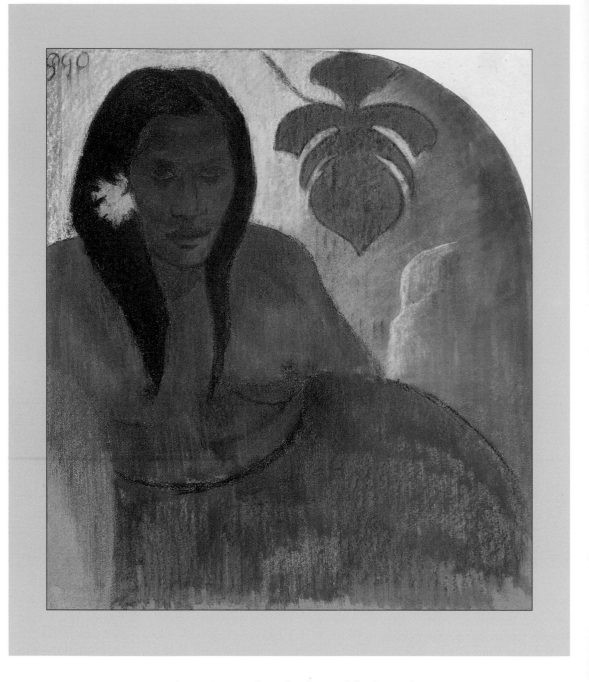

Soft pastel on paper with gouache underlay. Gauguin used pastel rarely, but here, working on a gouache underlayer, he was able to achieve a similar effect to oil paint using the clear, exotic colours which he loved, and using the edge of the pastel to outline the figure. The heavy, opaque yellow behind the blue-black hair serves to intensify the gaze of the girl. This is a good example of how changing the density of the pastel, coupled with sharp contrast in tone, can provide a focus of interest in the composition.

exotic settings such as the Court of Sardanapulus and the harem. Degas adopted much of his informality of pose and richness of colour but created a new environment for the nude – that of humble chores and everyday life – and his broad-hipped, amply bosomed, red-haired women seem to come alive under the pastel.

Degas had studied the suspended, foreshortened form which was a commonplace in the religious and allegorical subjects of the Baroque era, and a visit to a circus, the Cirque Fernando in Paris, gave him the idea for an experiment in viewpoint.

The star performer was an acrobat called Miss Lala, whose speciality was being winched up to the roof hanging on a rope by her teeth, and Degas drew her from below so that the viewer's eye is drawn upwards as a member's of the audience would be.

Degas was fascinated by 'snap-shot' impressions, and owned one of the first mass-produced Kodak cameras – he even interrupted dinner parties to have the guests pose for him. Far from regarding photography as a threat, he eagerly incorporated its lessons into his work, particularly when it revealed the possibilities of swooping or soaring angles and unusual compositions.

In the early 1850s he faced a personal and professional crisis. His eyesight was failing, and as he intimated to friends, he had allowed his painting to diverge along too many paths. He withdrew into his studio, where he was to produce his greatest masterpieces. Years before, he and Cézanne had admired Delacroix's canvas of *The Entry of the Crusaders into Constantinople*, particularly the figure at the lower right-hand corner of the painting, a captive woman on her knees with her hair falling forward over her face. Her bowed back appeared again and again in a succession of studies of women washing and bathing.

Degas made tracings of his own work, frequently reversing the image, or even counterproofing the original drawing. This is a method of transferring an image by placing a dampened paper on the work and then pressing gently all over it with the hand or a roller. The damp paper with its reversed image is then lifted off carefully, and can be fixed to a board with brown paper tape along the edges so that it will dry flat. The system of tracing and counterproofing can be repeated again and again, and is sometimes used to build up large compositions of many figures.

Towards the end of his working life Degas' pastel work became looser, with the form built up by a series of layers and hatchings, accentuating the fall of light on the figure. In the early stages, the pastel was frequently washed with water to form a very thin layer to take the later impasto. Each layer was sprayed with Degas' own secret fixative solution, and the final layer was frequently put onto paper slightly dampened by steaming. The soft pastel forms a very thick layer on the moist surface, an effect you can frequently see in the treatment of the hair.

This technique can only be used with a heavy watercolour paper or strong card. The surface must have a rough texture to hold the many layers and care must be taken to avoid blending the pastel, which will tend to flatten it. It is not an easy method, and in this context we should perhaps take note of Degas' own comment in a letter in January 1886: 'It is essential to do the same subject over again, ten times, a hundred times.'

POSING A MODEL

So how do we go about our own study? First there are a few practical matters to keep in mind. Even a professional model will need a five- to ten-minutes rest every half hour, and the room must be heated sufficiently, with a fan-blower preferably as an additional source. It you have not studied life drawing before – or even if you have – it is important to begin with very brief poses, lasting no more than from one to five minutes for the first 30-minute session. This will make you look at and draw the movement and form of the whole body together. Detail is not important, and making a few quick strokes with the end of the pastel to show the line of motion or using the side of the pastel to block in the mass of form will provide a good exercise so that in your longer poses you will know how to look at the whole pose.

Measuring

For short poses you will have time for no more than a quick impression, but for longer ones artists usually take some form of measurements, using the head as a scale. The following are, of course, only average measurements. A person is seven heads high. The elbows are in line with the waist, and hands reach down to the beginning of the thigh.

Measure the balance of the body from the clavicle, which is at the base of the throat between the collarbones. When a person is standing with the weight on one foot, the balance line runs from the clavicle through the arch of the foot which is carrying the weight, while if the weight is carried on both feet the line falls somewhere between. I always look at the clavicle first and draw the line of balance before proceeding with the rest of the sketch. If the weight is on one foot, the hip holding the most weight will be forced upwards, and the shoulder above will drop down to compensate.

SIMPLE
FIGURE SKETCH

Stage 1: I have used indigo for drawing in the figure and for putting in the shadow areas. These sketches, in soft pastel on tinted pastel paper, were both done in approximately ten minutes and are meant to record just the general movement and balance of the body. They are not intended to capture the details of the figure – that comes later.

Stage 2: When I was satisfied with the basic drawing and shadows, I used a light ivory pastel for the highlights to emphasize the forms. I asked the model to turn around and assume the same pose so that I would have a study of the same pose from both back and front. This is a good method for a quick sketch using two colours on tinted paper.

GIRL IN RED CHAIR

Stage 1: This again is a very simple drawing, but done with a charcoal stick. The background in this case is more important. First I have sketched in the basic form of the model, keeping it very simple.

Stage 2: I have divided up the background into interesting shapes that frame the model. You can use various elements of the room to help you – a wall can be darkened or the colour changed completely if this will help the composition, which is what I did here. I have used the side of the pastel to lay in the large, flat areas of colour in the background.

Stage 3: I have increased the colour in the background and overlaid the colours on the chair to deepen them. I have built up the form of the body by putting in some shadow areas, leaving them quite loose as I want the drawing to have a very fresh, spontaneous look. I have also redrawn some of the lines around the figure, and with the basic work done, have put in the details of the face and hands.

2

1

3

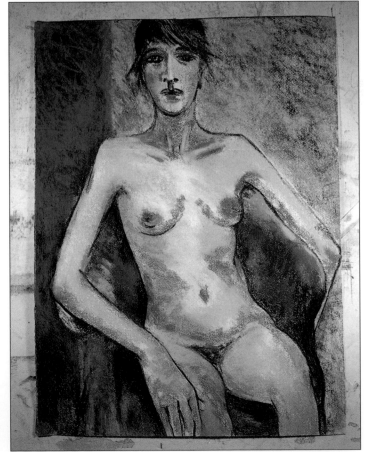

BACK VIEW DONE
WITH CHARCOAL
AND PASTEL

Stage 1: This is an unusual technique using charcoal and soft pastel on tinted pastel paper. I have blocked in the body with scene painter's charcoal which has given me a heavy mass which easily catches the direction of movement of the figure.

Stage 2: I am not using a fixative spray at this point because I want the soft pastel that I am putting in for the flesh tones to mix with the charcoal at certain points to give me the shadows of the body. Once I have laid in the basic flesh tones loosely, I will go over them again with a lighter-coloured soft pastel and put in the highlights. This time I will have to use a much stronger pressure so that the highlights will stand out. A light viridian has been added around the figure to produce a stronger outline and to clean up the rough edge of the charcoal. The cool green should create a sense of depth and make the body stand out against the warm background. This type of work can only be treated with a minimum amount of fixative spray because the light flesh tones will sink back into the dark charcoal when they are moistened by the spray.

This is done mainly using the point of the pastel to build up the form with lines, then the side of the pastel for the background. A heavy watercolour paper was used which produces a coarse texture. Many layers were applied with fixing between each of the layers.

1

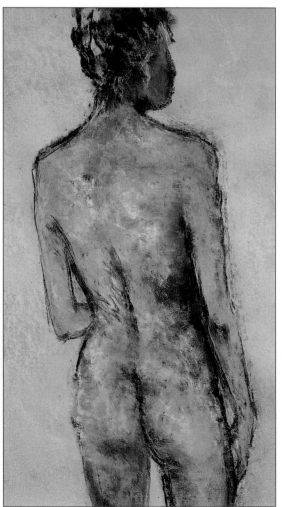

2

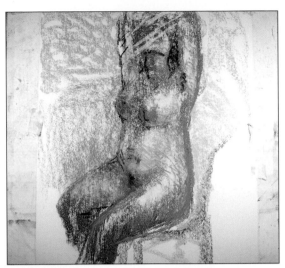

LEFT: *'Woman Undressing' – work in progress.*

BELOW: *The final pastel.*

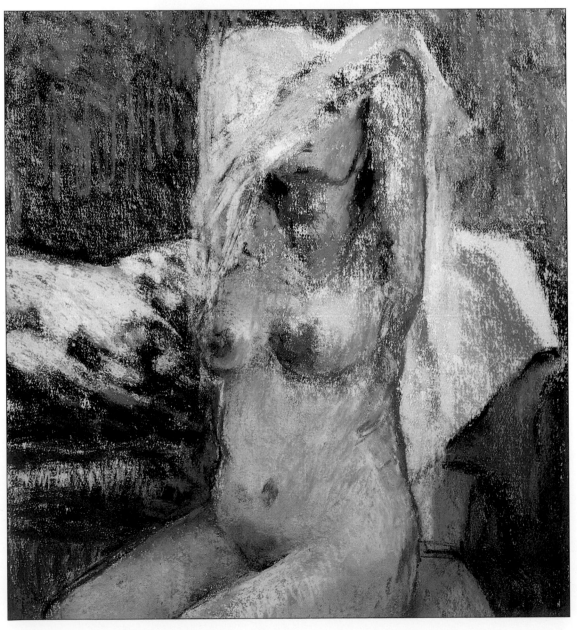

SEVEN

TROUBLESHOOTING

I have found that there is always a time when the first enthusiasm gives way to the realization that the painting or drawing is not working. This is a crisis common to all work, and most painters have devised their own little diagnostic tricks to find out what has gone wrong.

I believe it is a mistake to abandon any work without first finding out what the problem or problems are. If you fall prey to the temptation to take a clean piece of paper and start all over again you may simply find yourself facing the same problem again, so that you are unable to complete either one. For this reason I try to understand the problems and finish everything, regardless of the overworked mess it may become. The mistake can be caused by a lack of appreciation of the tones or colours in the composition, or it may be a simple problem of bad drawing. In any case, it is not difficult to correct in pastels, and many of my own and my colleagues' best paintings are the results of such struggles.

This kind of problem solving involves looking at the work in a new way. After working for a couple of hours on a painting you become so familiar with it you cannot really see it in an objective way, so the first thing I try is turning the work upside down. I fasten it to my painting wall with masking tape, dim the lights, which makes the colours less important, and leave the studio for a short break. When I return I can usually see if there is a problem with the tonal composition. To assess tone, it helps to half close your eyes so that you see mainly dark and light tones. As a general rule there should be a dark, medium and light tone, all providing contrast in an interesting pattern. There may be times when you plan a work with very slight tonal contrast, as in a very delicate drawing, but generally speaking the tonal structure of the painting is like a skeleton in a body – it gives it shape and form and holds it together. The larger the work, the more important this is. If you are having trouble with the tones you might want to try a work using just black and white or dark brown and white. If the problem is a tonal one it is very easy to correct this by overlaying darker tones of the same colours where necessary and accentuating the highlights.

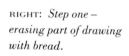

RIGHT: *Step one – erasing part of drawing with bread.*

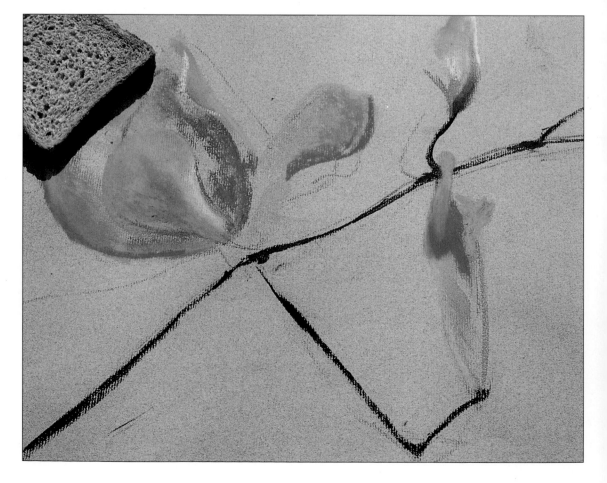

DRAWING AND PAINTING WITH PASTELS

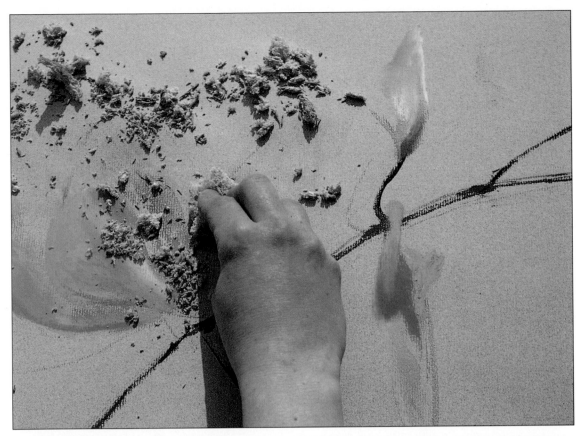

LEFT: *The pastel is gently lifted off the paper with bread.*

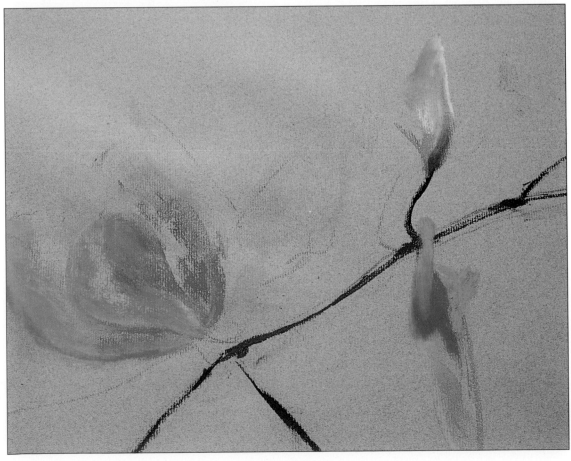

LEFT: *Completed erasure without damage to the paper's surface.*

117

TROUBLESHOOTING

The finished drawing of a magnolia blossom; dimensions 29½ × 21⅗in (75 × 55cm).

To check the drawing of a subject, hold the paper up to a large mirror. This will reverse the image and should show up a mistake which you may have been looking at for hours without noticing. People with strong astigmatism tend to stretch out their drawing along the axis of the distortion in their vision. So reversing the image immediately shows up this problem, and a simple correction can be made. Another way of reversing the image is to make a tracing of it and then turn the tracing over.

If you have to make corrections in the drawing, use fresh bread to lift the pastel off the paper without damage. This is much more satisfactory than a normal eraser, which will tend to smear the pastel into the paper, making a nasty smudge, and flatten and damage the paper's texture. Even a heavy drawing can be taken out if you use a sufficient amount of bread.

The last thing you have to look at is the colour. The most common problem is over-blending, which can make the work look somewhat tired, with a rather uniform texture. To correct this, give the work a good spray, leave it to dry for a few minutes, and then use a very soft pastel to go over some of the areas with fresh colour. Use a light touch to get a rough texture.

Another problem might be that you have used all warm colours, or conversely all cool colours. A balance of colours is important to keep the sparkle and tension in a composition. Remember that red and green are complementary colours, as are yellow and mauve, and blue and orange. Adding a complementary colour immediately enlivens a composition. When you add fresh colours you can use a soft pressure and allow the one underneath to show through in some areas, which will give an additional richness and a painterly quality to the work.

If corrections prove impossible on the particular paper, you can overpaint a part or the whole with white acrylic and allow it to dry for several hours. Pastel will go over this surface very well, and once dry, acrylic is impervious to both water and fixative. This method can only be used, however, if you are working on a heavy grade of watercolour paper which will not buckle and wrinkle when under the wet paint. When you apply the paint it will mix with the pastel, but this is an advantage, as it will provide a tinted surface on which to begin the new work.

If you cannot correct existing work but are satisfied with the image, you can use Degas' counterproofing to transfer it onto a fresh sheet of paper. It only gives you a faint image of the original work but this is enough to allow you to see the basic composition and work with it. First, lay your pastel work on the table. Do not use fixative. Take another piece of paper which you have soaked in water to make it soft and let the paper drain thoroughly before laying it on the drawing. Place it very gently by holding the two ends, making sure you are directly over the work to be copied because you cannot shift it around once you have put it on top of the drawing. When it is in position, rub it with a dampened sponge or your hand: you will have to press firmly. When the image has been transferred, you can check it by raising a corner; gently lifting off the paper, you then fasten it down with brown paper tape so that it will dry flat. The original pastel should dry without too much damage – and you have the reverse of the image to make into a new drawing. Now you can start all over again.

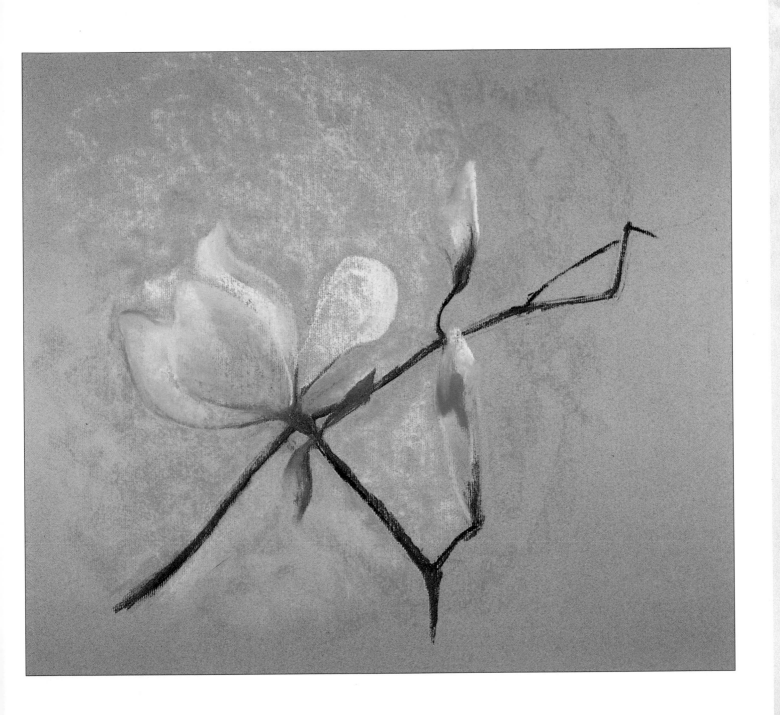

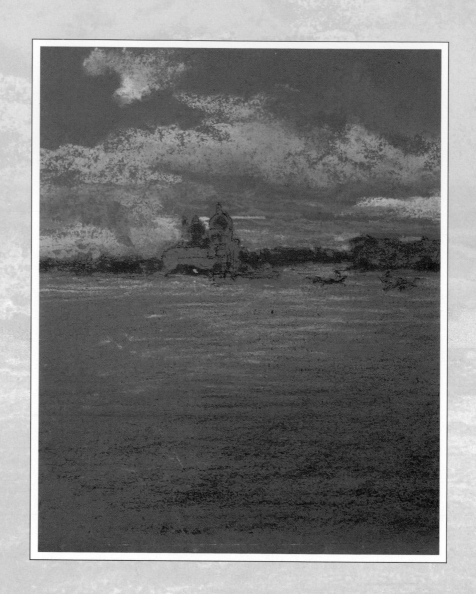

EIGHT

CONSERVING & FRAMING

Pastel is a fragile medium, and it is best to frame and glaze work that you are really pleased with to ensure that it is not accidentally smudged or ripped. There is also a danger from the effect of damp and dust. The framing and mounting process is really essential to ensure permanency, and framing your own work can give that added satisfaction of a job taken all the way through.

First, you must ensure that the drawing is securely fixed. It is wise to apply a very light, protective spray, even for a work that is to be glazed, because otherwise the pastel dust will drift down under the glass and soil the mount board.

If you cannot frame your work immediately, the best way of storing it is to lay it flat with a sheet of tracing paper over it. Several pastels can be stored one on top of another in this way, and a piece of heavy cardboard on top will keep them from moving and smudging. Newspaper is not recommended for this purpose since it is too soft and can smudge the pastel badly. Tracing paper has the necessary stiffness and waxy surface, and the works will be quite safe until you are ready to frame them.

Another, and even better method is to tape your work onto a piece of cardboard with masking tape at the corners, then cover it with tracing paper secured at the top with more masking tape. This keeps paper flat and prevents the tracing paper shifting over the surface.

If you are framing the work, it is essential to keep the pastel away from the glass. If there is contact with the glass for any length of time, moisture in the atmosphere will increase condensation on the glass; this will cause spots like pockmarking.

If you wish to make your own mount, you will need a craft knife and a steel ruler. (If you use an ordinary ruler the knife will cut into the edge.) Take the hardboard backing from the frame and simply mark out the shape on the mount board. Then measure your work, allowing ¼ inch (0.6 mm) overlap of the mount board on the painting. Generally the width of a mount is 3 inches (7.5 cm) around the sides and ½ an inch (1.2 cm) more at the bottom. The mount board should be fastened to the work top with masking tape before you begin cutting; a few pieces at the corners should stop it from slipping. Remember to protect the surface underneath: the knife can badly damage the table as it cuts through the mount in places.

The blade should be new so that you can make a clean cut with one pass of the craft knife. Once you have cut out the board, put it aside carefully. Now take the painting and lay it face up on the table. Pastels need special handling: you cannot put them face down on the back of the mount board for taping as you do with a watercolour, because they might smudge slightly from being laid face down on the table. I have devised my own method of putting pieces of masking tape underneath the corners of my work, with the ends sticking out. Then I lay the mount on top and position it. Once I have this done I press down on the mount so that the tape will stick. The painting with its mount are gently lowered into the frame with its glass. Now that the drawing's face is resting safely on the glass I can put on more masking tape to secure it firmly to the mount. The hardboard backing can then be fastened with pins or small cut brads, and brown paper tape put round the edges as a dust seal.

The painting can be framed without using a mount board, by inserting a small fillet of wood in the inner edge of the frame to separate the work from the glass. Paintings which have heavier layers of pastel look better without the mount board. The price of mount board depends on its durability. It is preferable to use conservation grade, as this will not yellow with time. There are many different colours of mount board. I usually prefer a light neutral or white board, but it is always interesting to see the work against different background tones and experiment a bit.

If you intend to exhibit your work it is inadvisable to use clip frames or metal frames; most hanging committees refuse to handle them because of the risk of breakage and injury. For exhibitions I prefer simple wooden frames, which can be fixed to the wall with mirror plates. Plexiglass is frequently used for large works because it is so much lighter than glass, although also more expensive. Glazing large pastels always presents a problem as the weight of glass requires a strong frame. I try to work on just one or two sizes of paper so that I can exchange the paintings whenever I wish and avoid expensive reframing. If you are doing the framing yourself, remember to put tape around the back to join the frame to the backboard. This seals in the painting and excludes dust.

RIGHT:
Protecting the drawing by taping it to card and then covering it with tracing paper.

RIGHT:

Putting the painting under the mount board: the tapes at the corners are sticky side up so that when you press down on the mount board, the pastel is held in position.

124

DRAWING AND PAINTING WITH PASTELS

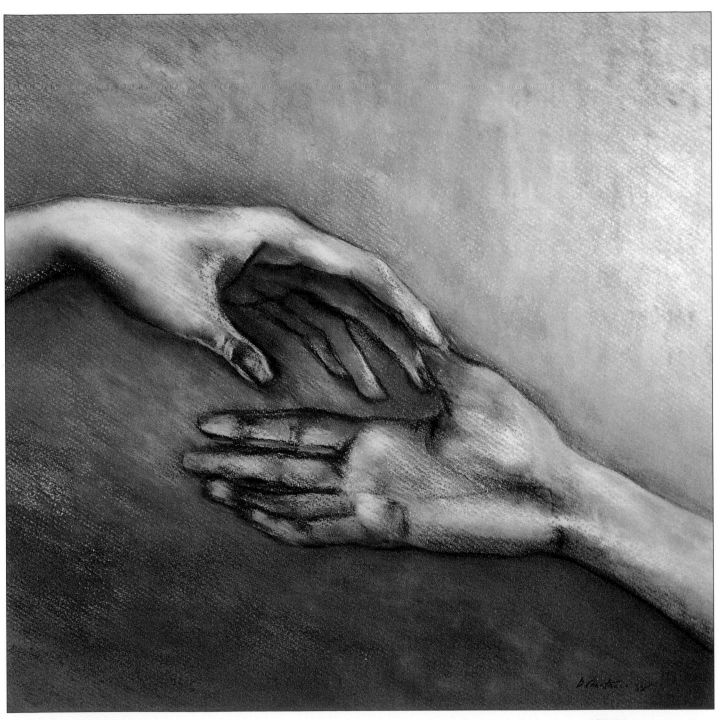

'Reach Out and Help.'
Pastel pencil and soft
pastel, dimensions 39²⁄₅
× 25³⁄₅in (100 ×
65cm).

INDEX

DRAWING AND PAINTING WITH PASTELS